KLIMT

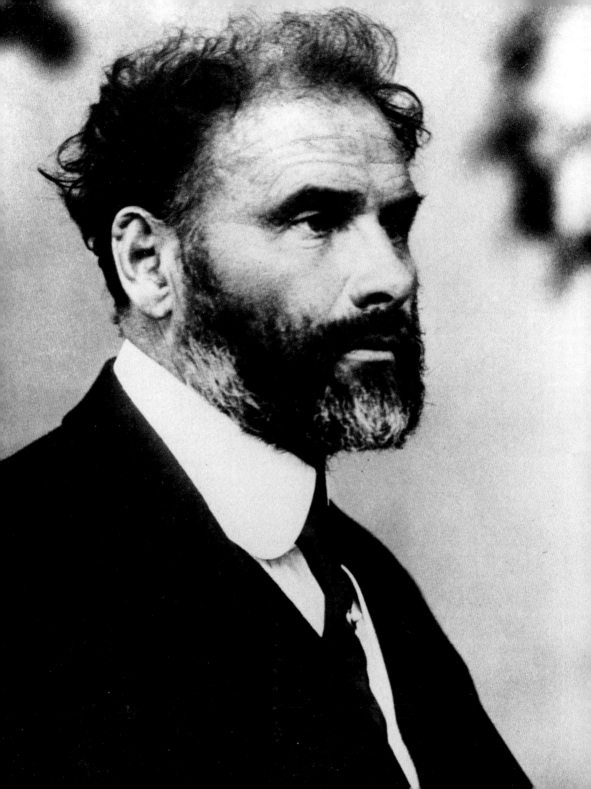

MASTERS OF ART

KLIMT

Angela Wenzel

PRESTEL
Munich · London · New York

Front cover: Portrait of Adele Bloch-Bauer I, 1907,
Neue Galerie New York (detail) (see p. 69)
Frontispiece: Gustav Klimt, c. 1916 (see p. 37)
pp. 8/9: Gustav Klimt, 1914 (detail)
pp. 38/39: Water Serpents II, 1904/07 (detail)

© Prestel Verlag, Munich · London · New York 2022
A member of Penguin Random House Verlagsgruppe GmbH
Neumarkter Strasse 28 · 81673 Munich

In respect to links in the book, the Publisher expressly notes that no illegal content
was discernible on the linked sites at the time the links were created. The Publisher
has no influence at all over the current and future design, content or authorship of the
linked sites. For this reason the Publisher expressly disassociates itself from all content
on linked sites that has been altered since the link was created and assumes no
liability for such content.

A CIP catalogue record for this book is available from the British Library.

Editorial direction, Prestel: Anja Besserer, Andrea Bartelt
Picture editing: Kerstin Pecher
Translation: Jane Michael
Copyediting: Sarah Quigley
Production management: Andrea Cobré
Design: Florian Frohnholzer, Sofarobotnik
Typesetting: ew print & media service gmbh
Separations: Reproline mediateam
Printing and binding: Litotipografia Alcione, Lavis
Typeface: Cera Pro
Paper: 150 g/m2 Profisilk

MIX
Paper from
responsible sources
FSC® C021956

www.fsc.org

Penguin Random House Verlagsgruppe FSC® N001967

Printed in Italy

ISBN 978-3-7913-8793-2

www.prestel.com

CONTENTS

INTRODUCTION

The Kiss comes in a gift box – a golden one, of course. As decoration on a coffee mug. There is virtually nothing that lovers of Gustav Klimt's art cannot purchase! The selection extends from prints to scarves and all sorts of bags to the aforementioned tableware and key rings. In short, the Austrian painter and draughtsman Klimt is undeniably a great favourite with the public. Indeed, his art offers much to delight us: beautiful women, an abundance of gold and ornamentation, lush flower gardens, summer landscapes – and, let's not forget, more than a hint of eroticism. In 2020 a private cultural organisation even boasted a magical journey into the 'very heart' of Klimt's art. The newly established Bassins de Lumières in Bordeaux, a centre for digital art in a former German submarine bunker, opened with the exhibition *Gustav Klimt, d'or et de couleurs* (Gustav Klimt: Gold and Colour). In a gigantic multimedia installation, Klimt's works were projected onto the walls, ceilings and floors and reflected on the surface of the water basin along with historical photos of Vienna.

But collectors also love Klimt – whether driven by passion or an interest in investment. His paintings are available for sale only rarely; they achieve record prices and rapidly increase in value. The current catalogue raisonné of the artist's works lists a total of 245 paintings, if the wall paintings in fixed locations are included. Nearly 200 of them have survived. Klimt worked on his paintings over long periods of time, repeatedly making changes and finding it difficult to part with them. Drawings, on the other hand, were no trouble at all, and executing them was a daily exercise. Some 4,000 to 5,000 sheets are still in existence as preliminary studies for paintings and autonomous works.

Public opinion of Gustav Klimt and his art during his lifetime was often divided, despite the fact that his career had begun very promisingly. He succeeded in rising from modest beginnings in a craftsman's family to become a well-paid artist who received public commissions and awards from the Austrian Emperor. He progressed from the position of a prospective drawing teacher to that of a recognised painter on Vienna's Ringstrasse, continuing the generally highly-esteemed tradition of academic history painting. But he was not satisfied with that. He ignored both the court taste and the expectations of the general public. His curiosity and openness led him along new paths. And so he progressed from decorative Salon painting to Symbolism and then to Art Nouveau. This was a trend which was also followed by

artists in other European countries including England, Scotland, France, Belgium, Germany and the Netherlands. With the Vienna Secession and the Wiener Werkstätte, Klimt successfully put the concept of the Gesamtkunstwerk in spectacular projects into practice. Around 1909 he developed a freer painting style of colourful intensity. The exchange with other artists, not only locally but also internationally, was of great importance for him. He also adopted and transformed influences from Byzantine art and from Japan and China in order to create his own style.

Klimt was highly esteemed by his fellow artists – both as a painter and as a person. He was a co-founder and the first president of the Vienna Secession, and was a congenial collaborator with the architects and designers Joseph Maria Olbrich, Josef Hoffmann and Koloman Moser. Klimt unreservedly promoted younger colleagues when they encountered opposition. He was the mentor of Egon Schiele and Oskar Kokoschka, who, like him, would become world famous.

Additionally, he enjoyed the esteem of clients and collectors from among the haute bourgeoisie. The elegant, attractive and self-assured ladies of Vienna loved to have their portraits painted by Klimt. To this day, he continues to be seen as a painter of women. But he was selective. If a face or type didn't interest him, he refused to accept the commission. Portraits of men are extremely rare in his oeuvre, nor was he interested in himself as a subject for his art. His works fetched high prices, enabling him to lead a comfortable life and he was very generous towards both his friends and his models. Money was unimportant to him. His main focus in life was his work.

After his death, Klimt quickly faded from public awareness. In the period after the Second World War abstraction became fashionable, and Klimt was relegated to the past. It was not until the 1960s that there was a revival of interest in his work. In recent years two catalogues raisonnés of his paintings have been published, and the catalogue raisonné of his drawings from the 1980s is currently being completed. It was largely due to Klimt that, around 1900, Vienna had become an important centre of art and design for Europe and the world. His new approaches to space and surface and to form and expression were groundbreaking for the generation of artists that followed. Today Gustav Klimt is regarded as the most important painter of Viennese Art Nouveau. That is reason enough to examine his oeuvre in greater detail, beyond the dictates of commercialisation.

LIFE

Vienna around 1900 was a golden age of Western culture. Like the age of the First Viennese School of classical music, the era forms a fixed building block in the self-image and branding of the 'world's most liveable metropolis'. Vienna during the age of Otto Wagner, Gustav Mahler and Sigmund Freud can stand comparison with the Florence of Brunelleschi, Donatello and Masaccio. But while fifteenth-century Florence can be classified under the historical term 'Renaissance', there is no equivalent term in the case of Vienna. What should it express? The 'final splendour' of which Otto Friedländer spoke – in other words, the moment marking the end of an era, the threatened decline of the world of the haute bourgeoisie against the background of the multi-national state which would collapse during the First World War? Or the 'Birth of Modernism', to borrow the subtitle of the permanent presentation that opened in the Leopold Museum in 2019? The fact that Gustav Klimt created pictures that have become icons for both aspects of 'Vienna around 1900' has certainly contributed in no small part to his fame.

Klimt was one of the many personalities from fine art, literature and music whose achievements helped to make Vienna the cultural centre of Central Europe between 1890 and 1918. Viennese architecture achieved international fame through the work of Otto Wagner, Josef Hoffmann, and Joseph Maria Olbrich, as well as that of their adversary Adolf Loos. Under the direction of Gustav Mahler, the Viennese Court Opera became one of the leading houses of the world. Composer Arnold Schönberg and his students Alban Berg and Anton Webern developed the 'Second Viennese School'. Alfred Adler founded individual psychology, and Sigmund Freud developed psychoanalysis. For Freud, sexuality was the driving force behind human actions. This was a disturbing theory at a time in which relationships between the sexes were marked by double standards, and eroticism stood for both taboo and seduction. Arthur Schnitzler, Hugo von Hofmannsthal, Hermann Bahr and Felix Salten, who belonged to the literary circle of 'Young Vienna', as well as their critics Karl Kraus and Peter Altenberg, were the writers who set the tone in the city. They gathered in the famous salons of the haute bourgeoisie such as that of Berta Zuckerkandl-Szeps.

Vienna in 1900 was a cosmopolitan city with almost two million inhabitants, which had undergone a meteoric development. The population had multiplied during the nineteenth century as a result of the arrival of immigrants from all the parts of the vast Habsburg empire of fifteen nations, as well as two city expansions. Emperor Kaiser Franz Joseph I had reigned since the end of 1848. In 1857 he had signed the decree for the construction of the Ringstrasse in Vienna, for which the city walls were demolished from 1858. Magnificent monumental buildings in the Historicist style were constructed along the Ring: the Vienna State Opera, the Parliament, the k. k. Österreichisches Museum für Kunst und Industrie – today MAK – Museum of Applied Arts – as well as the new Burgtheater, the University and the Neue Burg, an extension of the Hofburg. Wealthy industrialists and bankers – often Jewish – built city palaces along the Ringstrasse in

which they lived and carried out their business. The construction industry boomed, and even the panic of 1873 following the stockmarket crash could not interrupt the upswing for long.

Living conditions in Vienna varied considerably, however, and were characterised by tensions between the diverse nationalities, religions and social classes. There was a marked contrast between the wealth of the aristocracy and the haute bourgeoisie, between the middle classes who were struggling against social decline and the misery of the masses, who hardly had enough to survive. Gustav Klimt's parents lived in very modest circumstances. His father, Ernst Klimt, had arrived in Vienna from Bohemia at the age of eight and worked as an engraver. Gustav Klimt's mother Anna Klimt, née Finster, was a native of Vienna from the suburb of Margareten, in the 5th district. A cheerful woman with a positive attitude to life, she would have liked to become an opera singer.

The weather report for 14 July 1862, the day on which Gustav Klimt was born as the second child of his parents, listed very mild, calm conditions, cloudless both by day and by night. The single-storey house in which he was born lay in a rural district in the Vienna suburb of Baumgarten, west of the River Wien. Today Baumgarten lies in Penzing, in the 14th district of the city. Since 1967, a block of council flats has stood on the site of the house in which the artist was born.

Often Ernst Klimt did not earn enough to feed his family adequately as well as to cover the rent, as the family's frequent moves seem to indicate. Landlords mercilessly evicted tenants as soon as they were in arrears. After the stockmarket crash it became even harder for Ernst Klimt to support his family. There were seven children to feed: in addition to Gustav there was his elder sister Klara (1860–1937), who became mentally ill at a young age, Ernst (1864–1892), Hermine (1865–1938), Georg (1867–1931), Anna (1869–1874) and Johanna (1873–1950). Gustav was not the only one of the children who was artistically gifted. Ernst became a painter like his elder brother; Georg took up the profession of metal sculptor and medallist; Hermine was an embroiderer and left a notebook containing memories of her brother Gustav. Johanna married the bookkeeper Julius Zimpel in 1895. Her son Julius (1896–1925) became an artisan and was appointed head of the Wiener Werkstätte shortly before his death.

Like most people from the lower classes, Gustav Klimt attended the board school for eight years. However, he was curious, with a thirst for knowledge and perseverance. He would later acquire a comprehensive education by his own efforts. His artistic talent became evident while he was still at school. His teacher suggested to his parents that they should send him to the school of arts and crafts of the k. k. Österreichisches Museum für Kunst und Industrie (Austrian Museum of Art and Industry). This was a progressive institution that had been founded in 1867 on the initiative of Rudolf von Eitelberger, the first director of the museum. It aimed to promote taste and provide an artistic education for industrial designers, craftsmen and teachers for the industrial colleges, secondary schools and schools of drawing. Fine and applied art were to be closely linked. Artists who worked

Male Nude, 1883

Carl Schuster WIEN.

Ernst Klimt, c. 1890. Photograph by Carl Schuster, Belvedere Archive, Vienna, Franz von Matsch Estate

in both these fields were purposely appointed as professors. Architecture, sculpture and painting formed the basis of the curriculum and were to be applied to industrial art. The school followed the example of the modern English schools of design; the museum to which it was attached was modelled on the South Kensington Museum in London – today's Victoria and Albert Museum. Also founded by Rudolf von Eitelberger in 1863, it served to provide artists, industry and the public with a collection of samples and was the first museum of applied arts on the European continent.

During the entrance examination in October 1876, which he passed with flying colours, Gustav Klimt sat beside Franz Matsch, who was to become his friend and companion. Klimt's brother Ernst entered the school two years later, and his brother Georg trained there as a sculptor from 1889 until 1896. Gustav Klimt's initial career goal was to become a drawing teacher. The timetable included freehand and ornamental drawing, etching, genre and portrait painting and history painting. The Klimt brothers and Franz Matsch were encouraged by their professor Michael Rieser. For a fee, Rieser allowed his students to make large-format copies of his designs for the stained-glass windows of the Votive Church on Schottenring. Gustav also earned money with portrait commissions after photographs at five guilders each. During his third year of study, shortly before the state examination as drawing teacher, his talent, and that of his brother and Frank Matsch, was highly praised by Professor Rieser to Rudolf von Eitelberger – with resultant success. It was now decided that they

were to become painters. Young artists with a gift for decorative painting were urgently needed for the magnificent buildings of the New Vienna.

The three students each received a scholarship of twenty guilders per month and now studied in the painting and decorative art class under the direction of Ferdinand Julius Wilhelm Laufberger, a painter, graphic artist and illustrator. Laufberger was an expert in historical techniques of wall decoration and was awarded major commissions for the buildings on the Ringstrasse. He designed frescoes, sgraffiti, mosaics, stained-glass windows and stage curtains; he also designed ten- and hundred-guilder notes for the Austro-Hungarian Bank and glass engravings for Lobmeyr, the court glassware store. Laufberger was the main artistic role model for the three young painters, who, in 1879, joined together to form an artists' association called the 'Künstler-Compagnie'. Laufberger procured their first orders for them. He recommended them to the Viennese architecture practice Fellner und Helmer, which had built residences and business premises, villas and city palaces as well as a total of forty-eight theatres throughout the Danube monarchy, in the German Empire and in Switzerland. Most of the theatres are still in use today, including the Volkstheater in Vienna, the theatres in Zurich and Hamburg and the municipal theatre in Fürth. The first order received by the three young artists was for four allegorical ceiling paintings on the subjects of Poetry, Music, Dance and Drama, in the salon of the master builder Johann Sturany at Schottenring 21. Klimt took on the *Allegory of Music*. Thereafter the

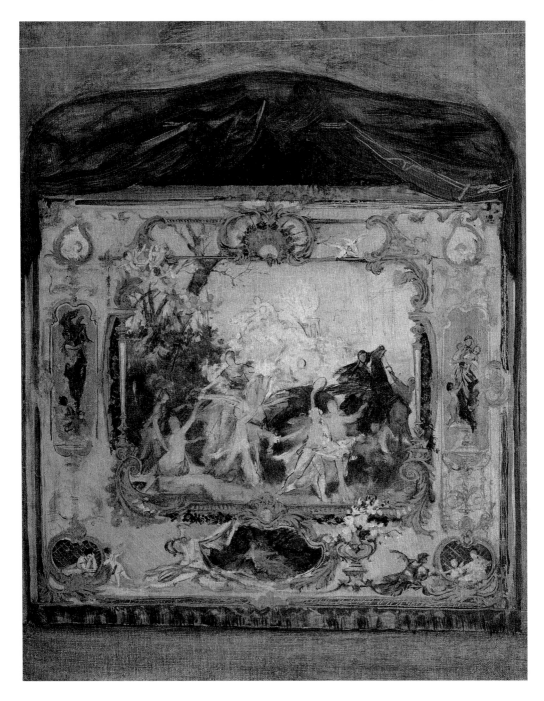

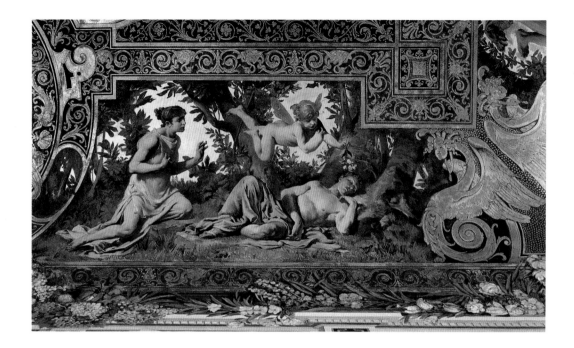

group designed the ceiling pictures of the concert hall in Karlsbad (Karlovy Vary) for Fellner und Helmer. After Laufberger's unexpected death in 1881 and the completion of their studies, the three master students remained at the School of Applied Arts for two further years, working together with their teacher's successor, Julius Victor Berger, and retaining the right to use the school's studio.

The Künstler-Compagnie received orders from all over Austria-Hungary. In 1881 they executed sgrafitto decorations in the municipal theatre in Brünn (Brno), and in 1882 to 1883 the ceiling painting and stage curtain for the theatre in Reichenberg (Liberec) – their master work and recommendation for further commissions. In 1883 the artists moved into their own studio at Sandwirtgasse 8 in the 6th district. This was followed by their cooperation on the furnishing of Peleş Palace in Sinaia, Romania, which King Carol I of Romania used as a summer residence:

they produced copies of paintings by Titian, Rembrandt and van Dyck as well as paintings after engravings for the ancestral gallery, and they designed sgraffiti, allegorical friezes and pictures. Often it is almost impossible to tell the styles of the three artists apart because they worked so well together. Between 1883 and 1885 they created decorative paintings for the municipal theatre in Fiume (Rijeka) and the National Theatre in Bucharest, and in 1886 for the municipal theatre in Karlsbad (Karlovy Vary).

In addition to these commissions, in 1883 Gustav Klimt contributed three painted allegories to the book *Allegorien und Embleme* (Allegories and Emblems), a reference work for artists and craftsmen. In them we can recognise the influence of the celebrated Vienna Ringstrasse and Salon artist Hans Makart and the Pre-Raphaelites. Now Klimt was a master himself, from whom others could learn.

Gustav Klimt, Franz Matsch and Ernst Klimt,
A Midsummer Night's Dream (Puck Mistakes Lysander for Demetrius).
Ceiling painting in the Hermesvilla, Vienna, 1884/85

In February 1884 the two Klimt brothers and Matsch addressed a letter to Rudolf von Eitelberger. They asked him to put in a good word for the Künstler-Compagnie with regard to the awarding of commissions for the decoration of new monumental buildings in Vienna, because they were most anxious to be able to execute a major work in their home city. It appears that the letter was not written in vain.

In October 1884, Hans Makart died at the age of forty-four. He had been summoned by the Emperor to Vienna, where he had carried out major commissions for the court. Together with other artists, the Künstler-Compagnie was awarded the task of decorating the Hermesvilla of Empress Elisabeth in the Lainzer Tiergarten. In 1885 the architect Karl von Hasenauer called upon them to continue the ornamentation of the two state staircases of the Burgtheater. Evidently he had a very high opinion of Klimt. The subject of the images, the development of the theatre from its origins in Antiquity until the present day, was specified by the artistic director, Adolf von Wilbrandt. Gustav Klimt took on four of the ten ceiling paintings and the tympanum of the southern grand staircase. On 14 October 1888, the theatre was inaugurated amidst great pomp. The Emperor awarded the Klimt brothers and Matsch the golden Cross of Merit.

They did not have to wait long for their next prestigious project. In 1881 the structural work for the court museums on the Ringstrasse had been completed. Gottfried Semper was responsible for the appearance of the exterior, and Karl von Hasenauer for the interior architecture. In 1882

Hans Makart had taken over the decoration of the staircases in the Kunsthistorisches Museum, but was unable to finish the work due to his untimely death two years later. In February 1890 the Künstler-Compagnie was entrusted with its completion: in other words, the design of the pendentive and the pictures between the columns. The programme was specified by Albert Ilg, the custodian of the Imperial Collections. The wall surfaces were to show the development of the different styles and were to be adapted to the existing works by Makart as well as the colour and material of the columns and pillars. Klimt took on thirteen of the pictures, including *Greek Antiquity*, *Egyptian Art* and six representations of Italian and Old Italian art. For this task he studied important works of art history, from which his own artistic development would profit. In the mural painting *Greek Antiquity*, the figure of the young woman emerging from behind a column already hints at Klimt's abandonment of academic Historicism. The woman is no longer wearing a historical costume, but modern dress. In the same year, Klimt was awarded the valuable Imperial Prize for his gouache *The Auditorium in the Old Burgtheater*, which is on view in the Künstlerhaus in Vienna.

Gustav Klimt and his two fellow artists had proved their expertise as Ringstrasse artists with the commission for the Kunsthistorisches Museum. In 1891 Gustav's brother Ernst married Helene Flöge, the daughter of Hermann Flöge, the renowned manufacturer of meerschaum pipes, and one of the two sisters of Emilie Flöge. This link with middle-class society was doubtless advantageous

for Gustav Klimt. In 1892 the Künstler-Compagnie moved into a garden studio at Josefstädter Strasse 21 in the 8th district. But then the situation suddenly changed. In July Klimt's father died unexpectedly of a fatal stroke; and in December Ernst died of pericarditis at the age of twenty-eight, following a neglected attack of influenza. It was a terrible blow for Klimt, because not only was his brother a family member and colleague but they had been the closest of friends. He took over the guardianship of Ernst's daughter Helene, who was only a few months old. The loss seemed to paralyse his creative work for quite some time. Moreover, the working partnership with Franz Matsch began to disintegrate following Ernst's death. There were disagreements. An order for a design for the main auditorium of the recently built Vienna University was awarded to the Künstler-Compagnie; as its representative, the recipient was Franz Matsch. Going behind Klimt's back, Matsch applied by submitting only his own designs, which, however, were rejected. Thereupon, Klimt became involved again. In September 1894, the Künstler-Compagnie was awarded the commission. In addition to ten tympanum pictures, Klimt took on three of the five large ceiling paintings with representations of the faculties of Philosophy, Medicine and Jurisprudence. Together with *Theology* they were to frame the central picture *The Triumph of Light Over Darkness*; the two latter were allocated to Matsch. In 1893 Klimt and Matsch were both proposed for professorships. But while Matsch was appointed professor of painting at the Vienna School of Applied Arts, Klimt was left empty-handed.

A conservative artist was appointed professor of history painting at the Academy of Fine Arts in Vienna. Although the Academy proposed Klimt on several occasions, he never gained a professorship. Nor did the court award him any further commissions. Franz Matsch, who appealed to the public taste, was at the height of his social ascent in 1912 when he was awarded a hereditary peerage.

Klimt was cut from a different cloth. He pursued his own artistic path without consideration for public opinion. In the 1890s he matured into an artist who insisted on his independence. In 1893 Nikolaus Dumba, the industrialist and patron of art and music, commissioned Klimt to furnish the music room in his city palace, which had been erected on the Parkring in the mid-1860s. Hans Makart designed the dining room, and Dumba commissioned Franz Matsch to design the study. The only interior-architecture project with which Klimt was entrusted was not finished until 1899. During this time he underwent a fundamental change. He abandoned entirely the Salon painting of the late nineteenth century and developed a symbolist style. In doing so his work was in harmony with the artistic endeavours in other European countries. The work of the Netherlands artist Jan Toorop, the Belgian Fernand Khnopff and the Swiss painter Ferdinand Hodler subsequently became particularly important to him. Proof of the change in his style can be seen in his portrait *Josef Lewinsky as Carlos in Clavigo* from the year 1895. In 1894 Klimt and his mother had moved to Westbahnstrasse 36 in the 7th district with his brother Georg and his sisters Hermine and Klara.

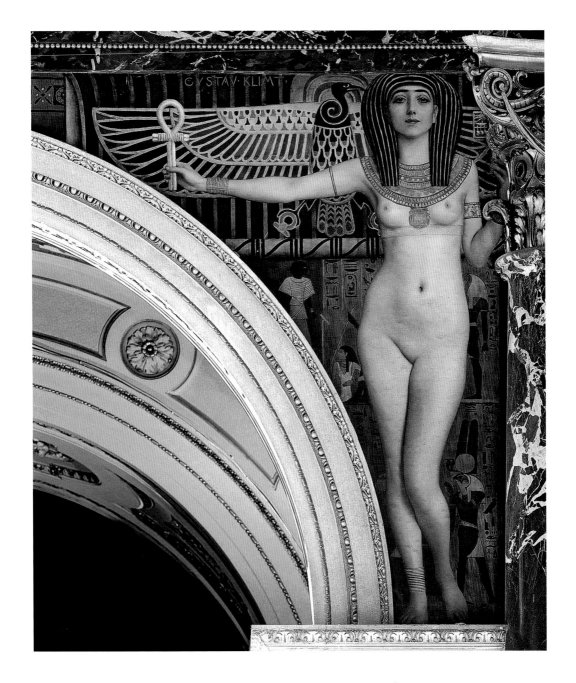

Egypt I. Spandrel above the grand staircase, Kunsthistorisches Museum, Vienna, 1890/91

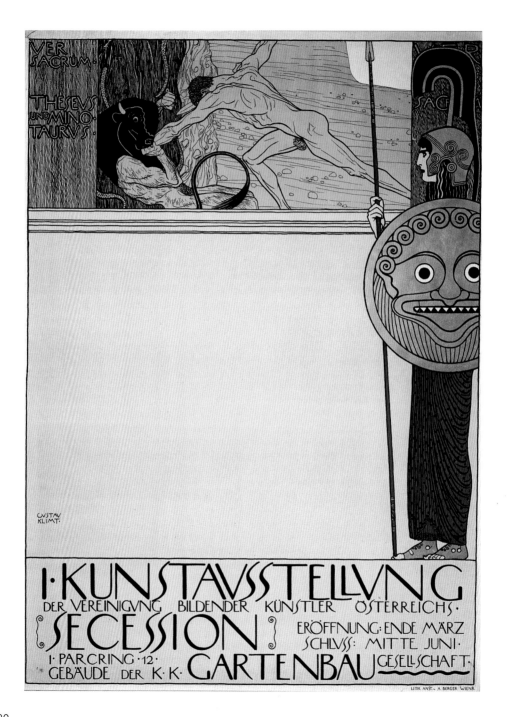

He would live there with his two unmarried sisters for the rest of his life. The first known correspondence between Klimt and Emilie Flöge, who was to be his life companion, dates from the year 1895.

Klimt's artistic integrity and straightforwardness were acknowledged by his progressive fellow artists. In 1897 Klimt became the leader and first president of the Vienna Secession, which was officially founded on 25 May. As early as 1892 the Munich Secession had split away from the artists' association there and had rejected the predominant conservative, academic Historicism. A year after the Vienna Secession was founded, the Secession in Berlin followed suit. In Vienna the exhibition business was changed by architects – especially the influential Otto Wagner, as well as his students and assistants Josef Hoffmann and Joseph Maria Olbrich – together with designers, painters and sculptors such as Koloman Moser, Alfons Mucha, Adolf Hölzel and Carl Moll, and the eighty-four-year-old Rudolf von Alt. At that time only the Society of Fine Artists offered presentation possibilities in the Künstlerhaus on Karlsplatz, where the works filled the walls and were hung above or beside each other without any overall concept. New international art was not shown. The Secession aimed to offer exhibition locations for the Austrian and international avant-garde, thereby encouraging artistic exchange and profiting from stimuli. They also wanted to raise the aesthetic understanding and taste of the public and arouse enthusiasm for the new art. The magazine *Ver Sacrum*, which was to be published at regular intervals and which was

elaborately designed in a square format with texts, illustrations and book decorations, would also contribute to this. Klimt created a large number of graphics for *Ver Sacrum*. In its publication lifespan of six years, reproductions of his works, articles about him and photos from his exhibitions were also published. One of the permanent staff and advisors of the magazine was Hermann Bahr, who, as he wrote in a letter, even regularly led groups of workers through the first Secession exhibition on Sunday mornings. Corresponding foreign members of the Secession included, to name only a few, the painters Eugène Carrière and Pierre Puvis de Chavannes, and the sculptor Auguste Rodin from Paris, the Berlin painter Max Liebermann, the painter Fritz Mackensen from Worpswede and the painter and sculptor Max Klinger from Leipzig.

The first Secession exhibition opened on 26 March 1898, in the building of the Horticultural Society at Parkring 12. It was a sensation. Together with a decoration committee, Hoffmann and Olbrich redesigned the Moorish-style rooms. The result was new and fresh, quite different from the Historicist design of the exhibitions in the Künstlerhaus with their dark walls and poor lighting, and pictures hung in several rows. Here the pictures were shown at eye level, the wall colours were carefully chosen and the ceiling was draped in white in order to distribute the light evenly. In addition to the artists of the Secession, important international colleagues also displayed their works, including Arnold Böcklin, Fernand Khnopff, Auguste Rodin, John Singer Sargent, Giovanni Segantini, Franz von Stuck and James Abbott

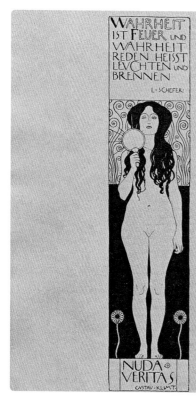

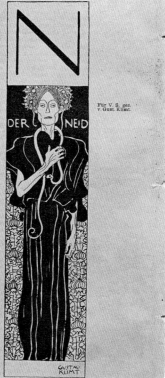

Charakteren aufdrücken wollte, so dass sie Gesinnungen und Leidenschaften possierlich und doch furchtbar äusserten; ich würde die ganze sichtbare Welt aufbieten, aus jedem das Seltsamste wählen, um ein Gemälde zu machen, das Herz und Sinne ergriffe, das Erstaunen und Schauder erregte."

Das ist die romantische Verwirrung, wie Tieck sie liebte; was seinen letzten Grund darin hat, dass die allmähliche Verwandlung des uranfänglichen Chaos in das bewusste Chaos den Grundgedanken der romantischen Philosophie, wie aller Entwickelungsphilosophie überhaupt, bildet.

Wem, der diese Phantasien über Malerei liest, drängte sich nicht Böcklins Name beständig auf die Lippen? Damals, vor hundert Jahren, färbten diese Gemälde-Träume den morgendlichen Himmel des neuen Jahrhunderts; die Wende unseres Jahrhunderts schmückt die wundervolle Wirklichkeit, die Erfüllung. Auch darin ist Böcklin der Künstler, den die Romantiker verlangten und prophezeiten, dass er Maler, Musiker und Dichter zugleich ist; nicht in der Weise der grossen Künstler der Renaissance, die oft mehrere Künste nebeneinander trieben: das Ziel des modernen Künstlers ist, den Geist mehrerer Künste in einer zu umfassen und auszudrücken. Wie fast jeder Prophet ein Moses ist, dem das gelobte Land höchstens von ferne zu schauen vergönnt ist, haben auch die Romantiker eine volle Verwirklichung ihrer Ideen auf dem Gebiete der Malerei nicht erlebt, und als sie endlich kam, war sie von ihren Zeitgenossen nicht heiss ersehnt, wurde nicht augenblicklich erkannt und willkommen geheissen; denn die Romantik war inzwischen erst verachtet, dann vergessen und als wunderbare, missdeutete Erscheinungen giengen die ersten Bilder Böcklins an der Mitwelt vorüber. Studiert

Allerdings auch auf die Malerei ihrer Zeit wirkten die Romantiker. Als ihren Ideen am meisten entsprechend rühmten sie den Landschaftsmaler Friedrich, Kaspar David Friedrich, aus Greifswald gebürtig. In seinen Bildern lebte die Stimmung der Ostsee, seines heimatlichen Strandes. Seine Vorfahren waren alle biedere gewerbtreibende Leute gewesen; er besass die strenge Rechtlichkeit, Gradheit und Abgeschlossenheit des nördlichen Volkes. Nie hatte er auch nur versucht, eine fremde Sprache zu erlernen, durch und durch deutsch war er und wollte es sein. Er wird geschildert als ein Mann von hagerem, starkknochigem Körper mit bleichem Gesicht und blauen Augen, die tief verborgen unter stark vorspringenden, buschigen, blonden Augenbrauen lagen. Er war von melancholischem Temperament, nie zufrieden mit seinen Leistungen, was zusammen ihn vielleicht dahin gebracht hatte, einen Selbstmord zu versuchen, an dessen Ausführung er gehindert wurde. Etwas dunkel Geheimnisvolles schien ihn zu umgeben. Studiert

Nuda Veritas and *Envy* from the magazine *Ver Sacrum*, no. 3, March 1898, page 12

McNeill Whistler. Klimt designed the poster, drawing on a Greek myth. It shows Theseus, who represents the Secessionists; Ariadne had given him a thread so that he could find his way back out of the labyrinth of the Minotaur after killing the mythical creature. The Minotaur stands for the tradition which had to be overcome. The goddess Pallas Athene, the guardian of art and crafts, served as the patron of the Secession. There were objections to the original version from the censor; thereupon Klimt added some tree trunks, one of which covered the genitals of Theseus. The motif also appeared on the cover of the issue of *Ver Sacrum* that coincided with the exhibition, while Athene adorned the cover of the catalogue, also designed by Klimt. The exhibition was a resounding success with 57,000 visitors and 218 works sold. Even the Emperor paid a visit: a high honour.

On 27 April 1898, during the exhibition, the foundation stone was laid for a new building for the Secession. It was erected after plans by Joseph Maria Olbrich on a plot of land on Wienzeile provided by the city and was handed over on 10 November after a construction time of only six months. The building is crowned by a golden cupola of 3,000 laurel leaves and 700 berries. Klimt influenced the design, and the painter and designer Koloman Moser contributed to the

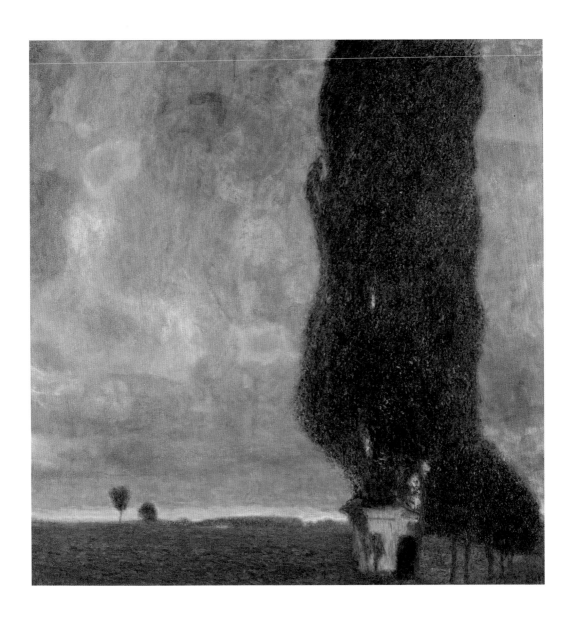

The Tall Poplar II (Advancing Thunderstorm), 1903

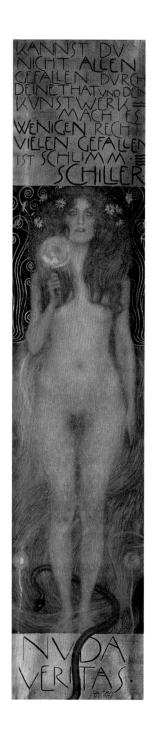

Nuda Veritas, 1899

furnishings. Georg Klimt made the entrance door after a design by Olbrich. Displayed on the façade was the motto of the Secession, which had been coined by Hermann Bahr: 'Der Zeit ihre Kunst. Der Kunst ihre Freiheit' ('To every age its art. To every art its freedom'). It was from this building that the radiance emanated that would make Vienna not only the national but also the international centre of fine art. Moreover, it marked a new beginning for Gustav Klimt, who now stood at the head of a radical artistic progressive movement which saw its ideal in the fusion of architecture, fine art and craftsmanship to form a Gesamtkunstwerk. Klimt subsequently developed his erotically charged Secession style, whose extravagant but rigorous ornamentation would culminate in pictorial creations like *Portrait of Adele Bloch-Bauer I* and *The Kiss*.

In the summer of 1898 Klimt travelled with the Flöge family to the Salzkammergut region for the first time. It was here, in St. Agatha on Lake Hallstatt, that his intensive study of landscape painting began. During the following year he again spent the summer holidays with the Flöges, this time in Golling near Hallein. He became the father of two boys, both of whom were given his first name. The mothers were his models Maria Učická and Maria 'Mizzi' Zimmermann, who gave birth to their second son, Otto, in 1902. The child died a few months later.

In 1898, Klimt discovered a new form of portrait in the commissioned likeness of the industrialist's wife Sonja Knips. He became the most sought-after portraitist for the attractive ladies

of Vienna's haute bourgeoisie. In 1899 he painted Serena Lederer, née Pulitzer, whom he had known since 1888. She and her husband, the industrialist August Lederer, who she had married in 1892, were important art patrons and supporters of the Vienna Secession. The portrait was shown in the 10th Secession exhibition in 1901, where it met with enthusiastic praise. Klimt received a princely fee – and the commission marked the beginning of a close and lifelong friendship with the family. The Lederers became Klimt's most important collectors and owned the largest private collection of his paintings. After Klimt's death, Serena Lederer purchased a large number of his drawings en bloc in the Galerie Nebehay in Vienna. August Lederer died in 1936, and the National Socialists confiscated his widow's property following the annexation of Austria. She was disenfranchised and died in Budapest in 1943.

In 1898 the controversy surrounding the allegorical Faculty pictures for Vienna University began. Klimt had been working on them for four years. When he presented the designs to the Commission of the Ministry of Culture and the Art Commission of the University in May, they demanded that he make changes. For example, as reported by Ludwig Hevesi, an art critic and ardent supporter of Klimt, one professor demanded that a nude female figure in *Medicine* should be replaced by a man – or should at least be shown clothed. Initially Klimt wanted to withdraw from the commission, but then he agreed to make some of the changes. Basically, however, he refused to change his concept. He suspected that there would be trouble when he displayed the completed picture *Philosophy* in the 7th exhibition of the Vienna Secession in 1900. However, the public furore exceeded even his worst fears. It was the biggest art scandal that Vienna had ever experienced. Karl Kraus was one of Klimt's most vehement critics. Several professors wrote an open letter, after which even questions were asked in Parliament. It was hoped that the presentation of the painting at the World Fair, which took place soon afterwards in Paris, would take the wind out of the sails of those who had disapproved of *Philosophy* in Vienna. This did not occur, however, although the work was awarded the 'Grand Prix'. The dispute continued when all three Faculty pictures were shown in 1903/04 in the Secession as part of the 'Gustav Klimt Collective Exhibition' with over eighty works. The gap was too great between the official optimistic view of science as the embodiment of clarity and progress and Klimt's representations, which showed doubt, suffering, the search for knowledge and man's helplessness at the mercy of the cycle of growth and decay. Moreover, Klimt's style had developed during the ten years in which he had been working on the paintings. The execution deviated from the designs. As a first step, the artist returned the commission for the pendentive pictures. On 3 April 1905 he wrote to the k. k. Ministry of Culture and Education, feeling that he was not being supported by them. He declared his withdrawal from the entire commission; he would not deliver the paintings and would pay back all the advance payments he had received. The Ministry, however,

wanted to force him to deliver the works. It was reported in the press that Klimt barricaded himself into his studio. When the influential journalist Berta Zuckerkandl-Szeps, a friend of the artist, read about this, she went to see him immediately, documented his angry outburst and published it as an interview – whereupon the Ministry withdrew its demands. Klimt had renounced his wages for ten years of intensive work. In order to have a sufficiently high ceiling for the large formats, he had even rented a second studio in the attic of Florianigasse 54 in the 8th district. August Lederer purchased *Philosophy* in the same year, thereby making it easier for Klimt to pay back the advance payments in May 1905. The three Faculty pictures, on which he continued to work until 1907, are regarded to this day as some of Klimt's most important works. They were destroyed by a fire at Schloss Immendorf in Lower Austria during the Second World War.

The dispute was also a quarrel about the role of the artist in society. The motto of the Secession, 'To every age its art. To every art its freedom', was not respected by large sections of the public. Klimt accused the state of patronising artists instead of simply acting as a facilitator and financier. The artist wanted to regain his artistic independence. He withdrew from the public stage and henceforth would work only for himself and his private clients.

However, during the 7th Secession exhibition, in the course of which the scandal erupted, some completely different works by Klimt were also shown: three landscapes, which harked back to his summer days in the Salzkammergut. From that time on, every year, he would dedicate himself to landscape painting. In 1900 he once again spent the summer holidays with Emilie Flöge and her family, this time at Attersee, a place to which they would return annually with just two exceptions. Klimt was seldom able to complete the pictures on the spot and continued to work on them in his studio in Vienna. In 1901 he once again showed landscapes in the Secession together with the controversial Faculty picture *Medicine*.

During November of that year an exhibition was planned in honour of Ludwig van Beethoven, the anniversary of whose death seventy-five years earlier was to be celebrated on 26 March 1902. The composer, who was considered to have brought the First Viennese School to perfection, had also had to fight for his role as a free artist. The exhibition was planned as a Gesamtkunstwerk par excellence, in which music, fine art, architecture and craftsmanship were to be fused seamlessly to form a whole. The exhibition had to be postponed, however, because the central work, a sculpture by Max Klinger from Leipzig, was not finished. The sculptor had been working for sixteen years on a monument to Ludwig van Beethoven that was to be over three metres tall and made from differently coloured types of marble and other precious materials. The opening finally took place in April 1902. Twenty-one artists participated, under the direction of Josef Hoffmann. The room design, wall paintings and sculpture formed a single vast artwork. Klimt made an important contribution with his *Beethoven Frieze*, which is dedicated to the composer's Ninth Symphony. In his formulation

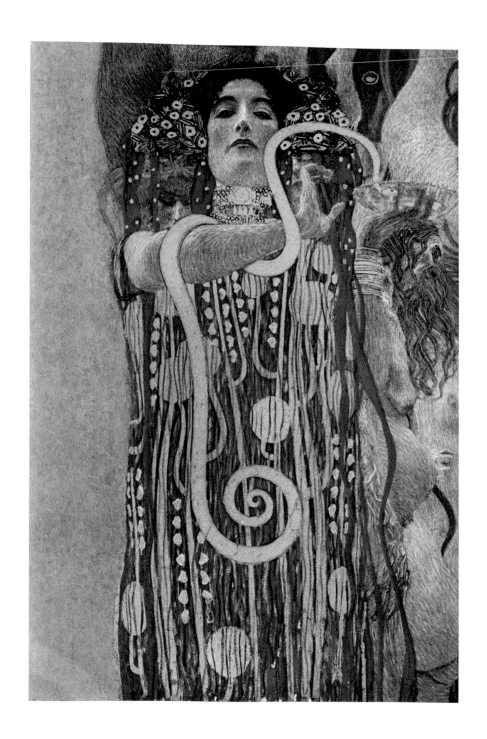

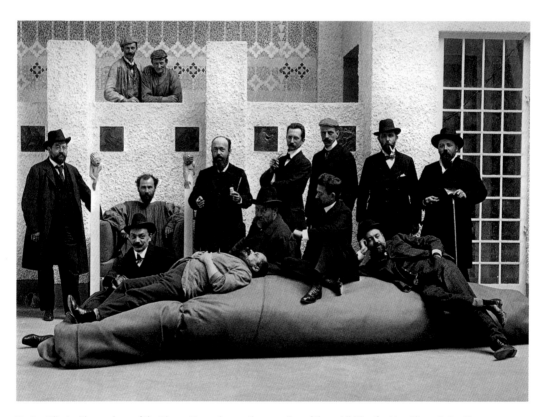

Gustav Klimt with members of the Vienna Secession on the occasion of the exhibition for Max Klinger's Beethoven sculpture in the Secession Building in 1902: from left: Anton Stark, Gustav Klimt, Koloman Moser, Adolf Böhm, Maximilian Lenz, Ernst Stöhr, Wilhelm List, Emil Orlik, Maximilian Kurzweil, Leopold Stolba, Carl Moll, Rudolf Bacher

of the allegorical content, Klimt had recourse to Richard Wagner, who described in a text the feelings and images which the symphony evoked in him. Wagner in turn had propagated the Gesamtkunstwerk in his writings and had realised it on the stage by fusing music, drama, dance and architecture to create a spectacle which was to appeal to all the senses. Nearly sixty thousand visitors attended the exhibition, but Klimt could not rejoice in unanimous praise. His fellow artists, including Ferdinand Hodler, praised the *Beethoven Frieze*, but critics saw it as evidence of corrupt morals and obscenity. The frieze was originally designed as a temporary work which was to be destroyed at the end of the exhibition. Instead, however, it was dismantled, purchased by the art collector Carl Reininghaus and sold to August and Serena Lederer in 1913. Stolen by the National Socialists, it was returned to the Lederers' son Erich after the collapse of the 'Third Reich'. Erich Lederer initially presented the work to the Österreichische Galerie (Austrian Gallery) Belvedere as a loan. After it was acquired by the state, the *Beethoven Frieze* was painstakingly restored, a project that took no less than ten years.

The Vienna Secession's aim of merging fine and applied arts in order to penetrate all aspects of life aesthetically led to the founding of the Wiener Werkstätte in 1903. The founding members were Josef Hoffmann and Koloman Moser, and the company was financed by Fritz Waerndorfer, an industrialist and art patron who functioned as commercial director. In contrast to the sinuous and luxuriant forms of French and Belgian Art Nouveau,

the participating artists developed a rigorous, geometric-abstract language of forms. They designed and produced furnishings, lights, household objects, fabrics and jewellery. Emilie Flöge and her sisters offered necklaces and brooches from the Wiener Werkstätte in their fashion salon, which they opened in 1904. Gustav Klimt gave his friend Emilie a number of items. In the spring of 1903, Klimt had travelled to Italy. He was so impressed by the mosaics in Ravenna that he returned there for a second visit in the winter.

One maxim of the Secession stated that there should be no distinction between 'art for the rich and art for the poor'. The beauty of everyday items should improve the lives and character of users from all social classes. The quality of the

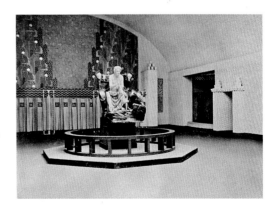

14th Secession exhibition, main room, with the Beethoven sculpture by Max Klinger in front of the mural *Die sinkende Nacht* by Alfred Roller, 1902

Palais Stoclet, Avenue de Tervueren, Brussels

materials and the craftsmanship should satisfy the highest requirements. Accordingly, despite their creators' social intentions, the products of the Wiener Werkstätte were too expensive for most people. The entrepreneur Victor Zuckerkandl, brother-in-law of Berta Zuckerkandl-Szeps, commissioned Josef Hoffmann to build a sanatorium for hydrotherapy in Purkersdorf near Vienna; the Wiener Werkstätte was responsible for the furnishings. The house became a meeting place for Viennese society, and was frequented by artists, musicians, writers and collectors. The most ambitious commission was that placed by the Brussels financier and company director Adolphe Stoclet and his wife Suzanne. They had lived for some time in Vienna where they had made the acquaintance of Josef Hoffmann, who was to build a house for them there. When they had to return to Brussels, they asked Hoffmann to design a city palace for them in the Belgian capital. The interior design was planned in cooperation with the Wiener Werkstätte. The house and its entire furnishings, from the cutlery to the candelabras

and the garden, formed a Gesamtkunstwerk, in which every detail was thought out with regard to the overall impression – even the kitchen and the servants' rooms. In 1904, Gustav Klimt was commissioned to create a frieze for the dining room, the *Stoclet Frieze*, on which he worked until 1911. The Palais Stoclet remains in the family's possession to this day and is included in the UNESCO World Cultural Heritage List. In 1913 the Wiener Werkstätte got into financial difficulties, which Waerndorfer averted with his private fortune. In 1915, however, he was forced to file for bankruptcy. Klimt's collectors Otto and Eugenia Primavesi saved the company, but were also financially ruined by doing so.

During the spring of 1905 disputes arose within the Secession between the 'Klimt Group', which supported the cooperation of architects, fine artists and designers in the interests of the Gesamtkunstwerk, and the pure artists surrounding the artist Josef Anton Engelhart, who took a conservative view. There had been ill feeling as early as 1904 when the Secession suggested to the

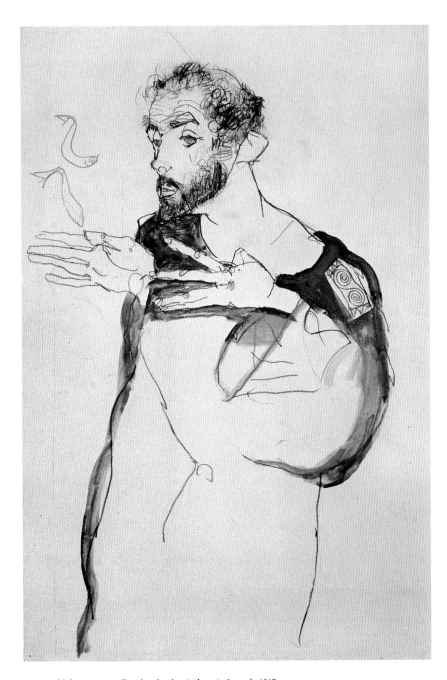

Egon Schiele, *Gustav Klimt in His Blue Painter's Smock*, 1913

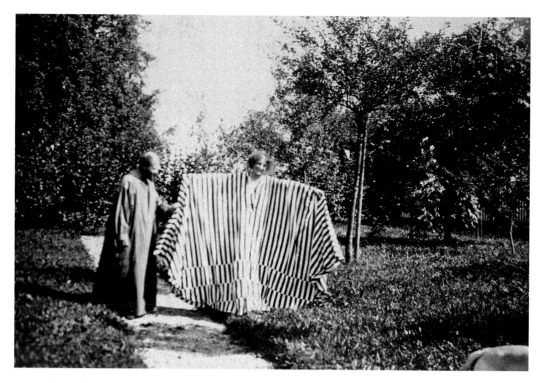

Gustav Klimt and Emilie Flöge (in a striped dress probably by Koloman Moser), 1908

Ministry of Education that they should represent the art of Austria at the World's Fair in St. Louis with a room furnished under the direction of Josef Hoffmann. Klimt was to exhibit *Jurisprudence* and *Philosophy*, as well as two landscapes. The plan foundered, however. The conservative painters also objected that Carl Moll, a member of Klimt's circle, had taken over an art dealership that would cooperate closely with the Secession. They feared commercialisation. A vote was held and the Engelhart group won, with a majority of just one vote. Thereupon Klimt and eighteen other members, amongst them Josef Hoffmann and Koloman Moser, resigned from the artists' association. Klimt's cooperation with the Wiener Werkstätte now became even closer. During the summer of

1906 he travelled to Brussels and London with Fritz Waerndorfer. The financier of the Wiener Werkstätte had not only had his dining room furnished by Hoffmann, but also a music room by the Scottish architect and designer Charles Rennie Mackintosh in 1902.

Klimt's connections with the national and international art scene were by no means impaired by his resignation from the Secession. In 1905 he travelled to Berlin for the opening of the first major exhibition by the Deutscher Künstlerbund (German Artists' Association), in which he and Ferdinand Hodler were both honoured with rooms of exhibits. In 1906 the Academy of Fine Arts in Munich elected Klimt as an honorary member, and the Österreichischer Künstlerbund (Austrian

Schloss Kammer am Attersee III (The Water Palace), 1909/10

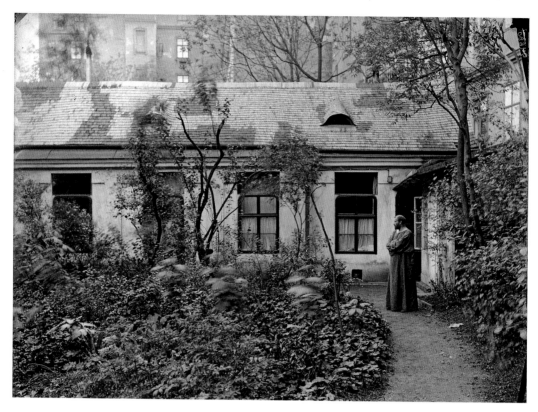

Gustav Klimt in the garden in front of his studio, Josefstädter Strasse 21, 8th district, Vienna, 1911

Artists' Association) was founded, to which he also belonged. In 1907 he exhibited his Faculty pictures in the Kunstsalon Keller und Reiner in Berlin, and visited the city again. The Klimt Group also had ambitious plans. In 1908 and again in 1909 they organised an art exhibition in a temporary structure of wood and plaster specially designed by Josef Hoffmann. It had fifty-four rooms, as well as terraces, gardens, a coffee house and a summer theatre. Klimt gave the opening speech at the first exhibition. It provided a comprehensive overview of all aspects of fine art and applied arts. He himself showed sixteen pictures. The second exhibition in 1909 was dedicated primarily to foreign artists including Pierre Bonnard, Paul Gauguin, Vincent van Gogh, Henri Matisse and Edvard Munch, as well as German and English applied arts, but Austrian artists were also represented. At Klimt's instigation Oskar Kokoschka was invited once more, although he had been a flop with the public at the first show. Also present was the young Egon Schiele, who was slated as an imitator of Klimt, but Klimt promoted both his young colleagues and supported them by purchasing some of their works. Klimt became a fatherly friend to Schiele and introduced him into the Lederer family. The two exhibitions had a restrained reception from the public and were

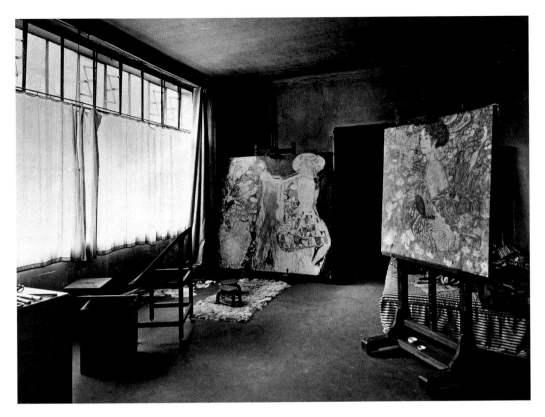
Gustav Klimt's last studio, Feldmühlgasse, Vienna

also financial failures. After that the Klimt Group organised no further exhibitions.

In October 1909 Klimt and his friend Carl Moll travelled to Spain via Paris. During this journey he experienced the art scene in the French capital and then visited Madrid, where he saw famous paintings in the Prado by Diego Velázquez, whom he greatly admired, before travelling on to Toledo. The works of El Greco which he saw there made a lasting impression on him. He subsequently changed his painting style; his colour schemes became more intense and his paint application more experimental.

Klimt continued to exhibit at home and abroad, especially in the German art centres Berlin, Munich and Dresden. At the International Art Exhibition in Rome in 1908 he was awarded a gold medal for *The Three Ages of Woman,* and in 1911 won the First Prize for *Jurisprudence.* In 1910 an entire room was dedicated to Klimt at the 9th Venice Biennale. In 1912 he became a corresponding member of the Berlin Secession and the president of the Österreichischer Künstlerbund (Austrian Artists' Association). Further awards included the membership of the Royal Academy of Arts of Saxony in Dresden in 1916. He was finally nominated an honorary member of the Academy of Fine Arts

in Vienna in 1917, after the suggestion that he be offered a professorial chair was rejected by the Ministry for the fourth time.

The summer holidays at Attersee with the Flöges were interrupted only by a joint holiday in Malcesine on Lake Garda, where Klimt also created two landscapes. Every year from 1912 until 1917 he also travelled to Bad Gastein with Emilie Flöge on a health cure. His close relationship with his sister-in-law evidently did not even suffer when he became the father of another son called Gustav in 1912. The child's mother was Consuela Camilla Huber, whom he had met in 1908. Their further children were Charlotte, born in 1914, and Wilhelm, born in 1915. Klimt's mother died during the same year.

The First World War had no effect on Klimt's painting. After the demolition of the property in Josefstädter Strasse, the artist moved into a new studio, a single-storey house with a garden in a quiet location at Feldmühlgasse 11 in Unter St. Veit, in Vienna's 8th district. Commissions were not as numerous as they had previously been as a result of the deteriorating situation, but Klimt appears to have been able to survive these years reasonably well with the support of his collectors. In 1917 he journeyed twice to the country estate of the Primavesis in Winkelsdorf.

Klimt did not live to see the end of the war, the fall of the Danube monarchy and the final extinguishing of a glittering and pioneering age. On the morning of 11 January 1918, as he was getting dressed, he suffered a stroke which paralysed him on the right-hand side. After a short period in a

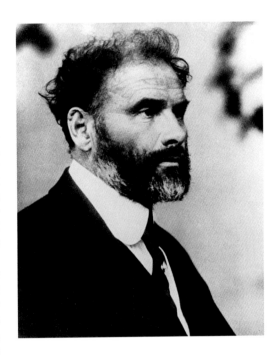

Gustav Klimt, c. 1916

sanatorium, he had to be admitted to the General Hospital, where he died of pneumonia associated with influenza on the morning of 6 February. Egon Schiele drew the emaciated face of his friend in the mortuary. The pictures *The Bride* and *Lady with a Fan* remained unfinished on the easel in Klimt's studio.

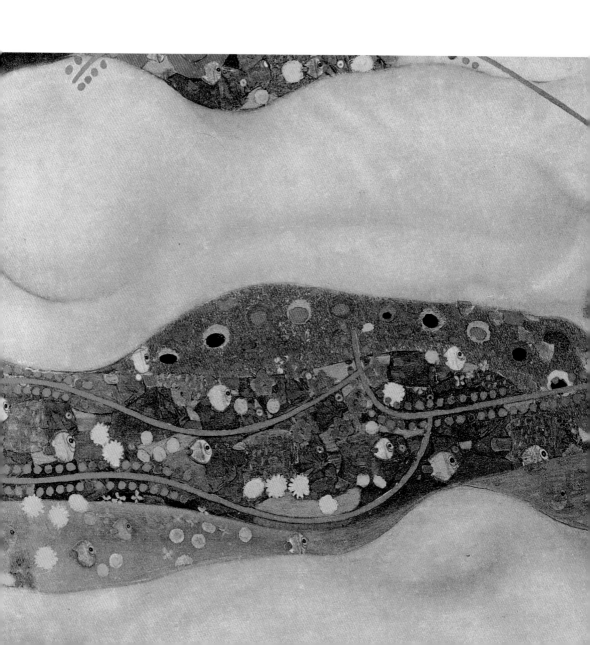

WORKS

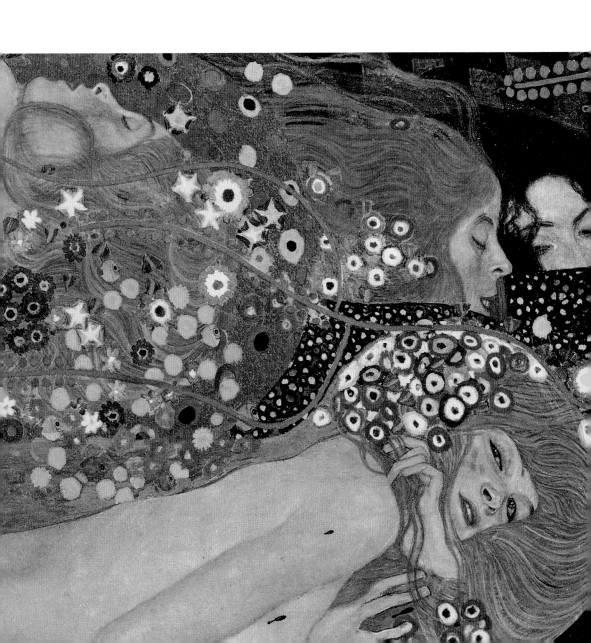

The Theatre in Taormina, 1886–1888

Oil on marble plaster
c. 750 × 600 cm
Burgtheater, northern staircase, Vienna

Gustav Klimt, his brother Ernst and their colleague and friend Franz Matsch had
achieved their goal. Their artists' association 'Künstler-Compagnie' had received
a commission for a project in Vienna which promised great fame: to paint
the stairwells of the two grand staircases in the new Burgtheater on Vienna's
Ringstrasse. The pictorial programme was to show the development of the theatre
from Antiquity to the present day. The artists first transferred their coloured designs
in full size onto cardboard using pencil, graphite and charcoal; then they perforated
the outlines and traced them onto the ceiling through the holes using graphite
dust. Finally, they executed the painting directly onto the plaster.
Gustav Klimt designed one of the two tympanums of the staircases and four of the
ten ceiling paintings, including *The Theatre in Taormina*. The theatre in the town
in Sicily was built by the Greeks during the third century BC. Later it was extended
by the Romans so that they could stage races and gladiatorial fights there. It is
famous for the view across the sea and the eastern coast of Sicily with Mount Etna,
a panorama which Klimt has depicted here. We cannot see much of the theatre,
however; it lies in front of the bay in the background. The scene itself is set in a
Roman villa high above the city. The main figure, who attracts all the attention,
is a nude dancer. She is moving to the music of a similarly naked woman playing
an aulos, and another, dressed in red, who is playing the tambourine. Shades of
brown, broken white, gold and a deep, warm red lend the painting an impression
of luxury. Klimt may have borrowed ideas for both his figures and the architecture
from the scenes from Antiquity by the Victorian painter Sir Lawrence Alma-Tadema.
The latter was a member of the Academy of Fine Arts in Vienna. Another reference
was the 'painter prince' Hans Makart, who had been awarded major commissions
for the buildings on the Ringstrasse. Painting nude women was certainly permitted
in nineteenth-century Vienna if they were shown in an antique context. Nonetheless
the scene was criticised as having very little to do with the theatre of Antiquity,
and rather focusing on sultry eroticism. At the same time, the powerful colours
were admired. All in all, Klimt's works for the two monumental stairwells in the
Burgtheater were highly praised. Emperor Franz Joseph I awarded him the Golden
Cross of Merit for his achievements.

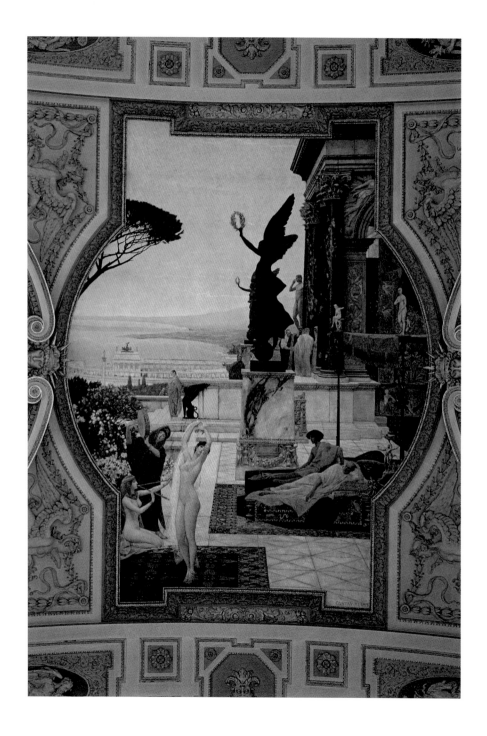

Josef Lewinsky as Carlos in Clavigo, 1895

Oil on canvas
60 × 44 cm
Belvedere, Vienna

Gustav Klimt first gained recognition as an artist with the interior decoration of theatres. In 1888 his gouache in the auditorium of the old Burgtheater caused a sensation. Drama and the theatre are also the subject of this painting, in which he broke away from the Salon painting of the Gründerzeit and progressed to the expressive form of Symbolism.

In 1894 Klimt had been commissioned by the Gesellschaft für vervielfältigende Kunst (Society for the Reproductive Arts) to paint the portrait of an actor of his choice from the Burgtheater. The likeness was to serve as the template for an illustration in the luxury volume *Die Theater Wiens*. Klimt decided on Josef Lewinsky, who had been a life member of the Burgtheater since 1858. He portrays him in one of his star roles as Carlos in Johann Wolfgang von Goethe's tragedy *Clavigo*. Klimt worked for more than a year on the portrait, probably with several model sessions and with the help of photographs. Unlike the Historicist portrait grisailles by his artist colleagues, Klimt's painting for the planned publication is extremely modern. He has divided the format vertically into three sections. Our gaze is directed straight towards Lewinsky's illuminated face, which is worked out in great detail in the main section. The figure in its black costume fades into the background of the darkened stage. The collar, jabot and cuffs are delicately painted and shine out in white; the buttons on the sleeves, the watch chain and the silver shoe buckles gleam in the stage lighting. Two golden bars with the picture title, signature and year of creation, which complete the actual portrait at the top and the bottom, underline the actor's importance. The two other sections of the painting are unusual. To the left, golden ivy – a symbol of immortality – trails downwards against the background, which is executed with casual brushstrokes in shades of grey. At the top of the picture we can discern laurel twigs, which stand for fame and honour, like shadows behind the tendrils. In the right-hand panel there is an ancient tripod with a vessel from which smoke is rising. A young woman is emerging from the smoke, hovering with a theatre mask of an old woman in her hand. Behind her is a man's face mask. With this symbolism Klimt refers back to the origins of European theatre in Greek Antiquity. He positions the achievements of the highly esteemed Burgtheater actor Josef Lewinsky in this millennial tradition and thus intentionally underlines his significance.

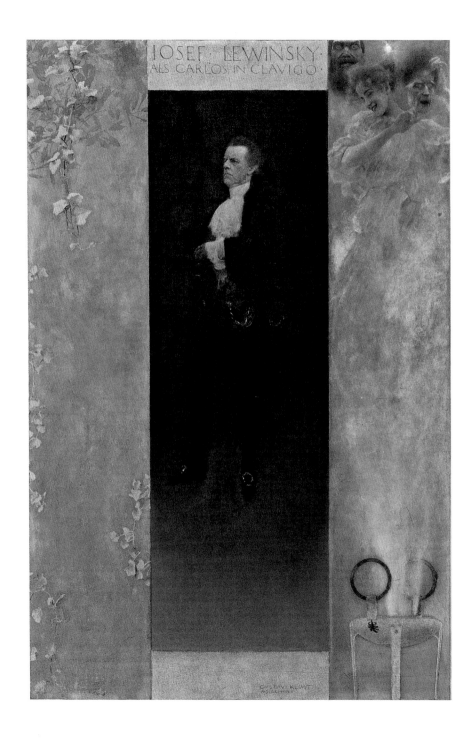

43

Portrait of a Lady with Cape and Hat, 1897/98

Black and red chalk
44.6 × 31.8 cm
Albertina, Vienna

For Klimt, drawing was a daily exercise – indeed, a daily necessity. The sheets were piled up in his studio: sketches, preliminary studies for paintings, and drawings which were created as independent artworks. The human figure formed the main focus of his drawings; few landscapes have survived. Even in his early years, Klimt was an excellent draughtsman. He prepared his Historicist decorative paintings with precise studies and sketches. During the 1890s he turned his attention to Symbolism. He produced anonymous portraits such as this *Portrait of a Lady with Cape and Hat*. The chiaroscuro is created with subtly graded hatching, sometimes across largish areas, recalling the Neo-Impressionist drawings of the French artist Georges Seurat. The young woman's large, dark eyes attract the viewer's gaze but do not respond to it. She is gazing sideways with a blank, slightly sad expression, her head gently inclined. A strip of light behind her hints at a section of window, through which a soft light is falling onto her face, emphasising the bridge of her nose before being reflected in the outer corner of her left eye. In order to achieve this effect, Klimt left the background paper in its original state. The face acquires a sculptural quality through the treatment of the lighting. The economy of the lighting highlights the mysterious mood of the drawing. It is enhanced by the black cape and the feathery stand-up collar, which plays around the lady's cheek. For the cape, Klimt first applied a uniform area of colour, followed by dense black chalk strokes which follow the lines of the garment. He has drawn the decoration on the hat with casual circling lines that contrast with the bright paper ground of the strip of light, and uses red chalk to delicately colour the model's curly hairstyle.

The materials Klimt used in his drawings remained the same over many years. Initially he worked – as here – on packing paper with black chalk, sometimes adding coloured chalks. From 1903/04 he used lighter, stiffer paper in a larger format that he had sent from Japan, and worked in pencil with the addition of crayons. During his 'Golden Phase' he also added gold and silver paint and watercolours. He rarely used pen and ink. For a long time Gustav Klimt's drawings were more highly appreciated than his paintings.

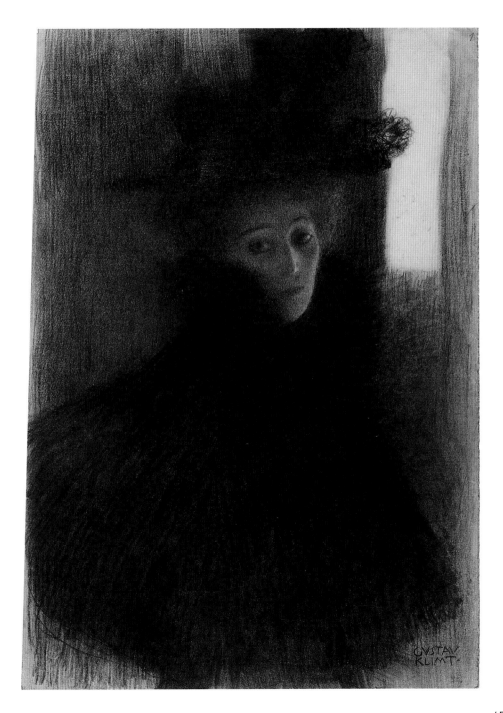

Portrait of Sonja Knips, 1897/98

Oil on canvas
145 × 146 cm
Belvedere, Vienna

A dream in pink tulle. And a shimmering piece of painting. The young woman was born in 1873 – aristocratic but poor – as Sophie Amalia Maria Baroness Potier des Échelles in Lemberg, present-day Lviv in Ukraine. In 1896 she married one of the richest men in Vienna, Anton Knips, the co-owner of the ironworks C. T. Petzold & Co. He financed his independent-minded wife's passion for Viennese Modernism. At her instigation Josef Hoffmann designed the family's city apartment, as well as a country house in Seeboden by the Millstätter See, a new villa in Döbling and the family tomb. Sonja Knips was a regular customer of the Wiener Werkstätte and the fashion salon of the Flöge sisters. She knew Gustav Klimt before she was married. Did she have a love affair with him? Sonja Knips was at the very least a close friend of the artist, because he gave her one of his sketch books in red leather – like the one she is holding in her hand. She also owned two further paintings by him.

In this commissioned portrait, Klimt adopted a new approach. For the first time he chose a square canvas, a format which he soon came to prefer. The composition is divided diagonally into two halves which are held together by the blossoms at the top edge of the picture. James Abbott McNeill Whistler's portrait of his mother (1871) served as inspiration for the work – it would later appear in many popular films and in 1997 would even play a leading part in a Mr. Bean film. Klimt's portrait lives from its contrasts: light and dark, strong and delicate colours, a casual yet precise painting style. The background remains indeterminate. Is Sonja Knips sitting in the garden or in a house in front of a vast flower arrangement? Here, Klimt refrains from a more precise depiction, in order to show the main subject to best advantage all the more clearly. Even the armchair and Sonja Knips's hands are only hinted at. Her face, on the other hand, is executed in almost photographic detail. We feel as if we could reach out and touch her wavy hair. The contrast lends the composition tension, which Klimt would go on to develop further in later portraits. The blossoms are shown two-dimensionally and do not recede; they hint at the future ornamentation in his paintings.

The sensation in this painting, however, is the dress of superimposed brushstrokes in variations of delicate pink. The fabric almost seems to rustle. At the same time it is painted quite freely. The portrait adorned the dining room of the Villa Knips, which Josef Hoffmann had designed.

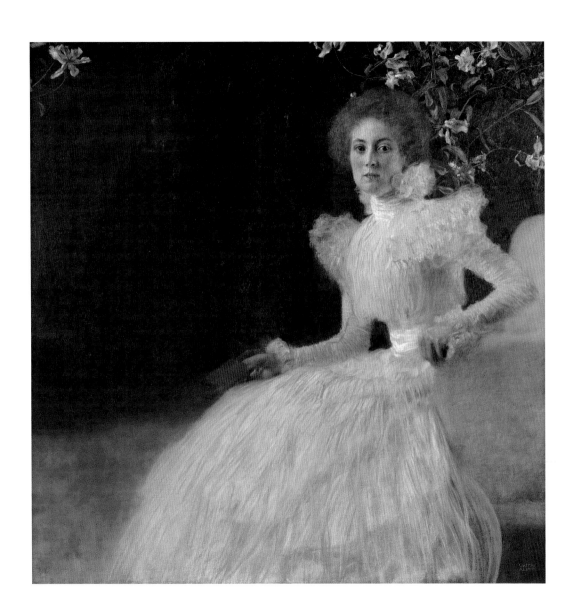

Nuda Veritas, 1899

Oil on canvas
252 × 56.2 cm
Theatermuseum, Vienna

The naked truth – that was the artistic authenticity for which Gustav Klimt stood, together with his fellow artists of the Vienna Secession, which they had founded in 1897. He was the group's first president. The figure of *Nuda Veritas* presented by Klimt is shown facing the front, unclothed and vulnerable. It is an allegory in line with art-historical tradition. In 1494/95 Sandro Botticelli had presented Truth as a beautiful nude woman in his painting *The Calumny of Apelles*; she stands with her head erect and her right hand raised towards heaven. However, she has covered her pubic area with a veil and her left hand. While the figure of the Italian artist is quite clearly not of this world, Klimt presents the 'naked truth' in front view and firmly in the here and now. Admittedly, he provides her with symbolic attributes like the mirror with the light of truth as well as the two stalks of dandelion and the serpent at her feet. Her vulnerability and innocence are emphasised by the delicate blue veil, the dandelion clocks and the daisies in her hair. But at the same time she is an image of new life, not idealised and other-worldly, but utterly present. Klimt's model may have been Maria 'Mizzi' Zimmermann, with whom he had a relationship and who became the mother of his son Gustav in 1899.
'Nuda Veritas' appeared as early as 1898 as a small figure with outstretched arms and as an attribute of Pallas Athene, the patroness of the arts and sciences, whom Klimt depicted programmatically as a modern champion of art representing the claim of the Vienna Secessionists. In the same year he drew a 'Nuda Veritas' using Indian ink to illustrate *Ver Sacrum* (Sacred Spring), the magazine of the Secession. The goddesses of Antiquity in Klimt's Historicist paintings for the new Burgtheater and the Kunsthistorisches Museum on the Ringstrasse became crown witnesses of the new art. Klimt was repeatedly subject to public criticism. *Nuda Veritas* is a reaction to that. The artist answered with a quotation by Friedrich Schiller, with which the latter had countered hostile judgements: 'If you cannot please everyone with your deeds and your art, please a few. To please many is a bad thing.' *Nuda Veritas* was shown at the 4th exhibition of the Vienna Secession and was violently rejected by the public.

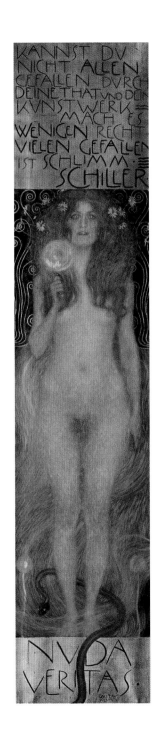

On Lake Attersee, 1900

Oil on canvas
80.2 × 80.2 cm
Leopold Museum, Vienna

A 'frame full of lake water' was the Viennese art critic Ludwig Hevesi's admiring description of this painting when it was displayed in 1901 in the 10th Secession exhibition. During the year in which it was created, Gustav Klimt spent the summer holidays with the Flöge family by the Attersee for the first time; from then on, they were to return there almost every year. Klimt escaped from the heat of summer in the city and sought relaxation and rest in order to work. He loved nature. In the Salzkammergut he could go for walks and undertake long hikes, go rowing and swimming, read, enjoy the company of Emilie Flöge and her family, reflect – and of course paint. For the sojourn of over three weeks, from mid-August to mid-September of 1900, he took six canvases with him, and reported in his holiday correspondence that he was working on five landscapes, including this painting.

Until 1907 the Flöges and Klimt stayed in the Bräuhof in Litzlberg. Looking out from the shore across the lake, one could see a small peninsula on the right with the castle that gave the village its name. Klimt has hinted at it at the top right edge of the picture. Hevesi formulated the basic idea of the composition very accurately with his comment: the surface of the water almost entirely fills the picture format. Towards the top it blurs into mist or fog. Against a greyish-purple background, Klimt reproduces the gentle movement of the little wavelets and their light reflections with countless blue-grey and turquoise-green brushstrokes giving way to white ones on the right-hand edge of the picture. They become smaller and smaller towards the top, until they are replaced by stripes of turquoise and grey-blue-purple which lend depth. We can vaguely make out the line which separates the surface of the water from the mountains behind. The group of trees on the island, with the two clouds above cut off by the edge of the painting, is echoed in the mountain slope on the left, above which another cloud is hovering. Klimt creates an impression of spatiality through the difference in brightness and the use of an aerial perspective which fuses the colour of the landscape elements in the distance with those that are even further away. In his later landscapes he was to depict the sky only rarely: a result of his investigation of the tension relationship between depth and surface, real space and pictorial space. *On Lake Attersee* represents a milestone in the development of Klimt's approach to landscape. The picture expresses his deep understanding of nature and is at the same time an outstanding piece of pure painting.

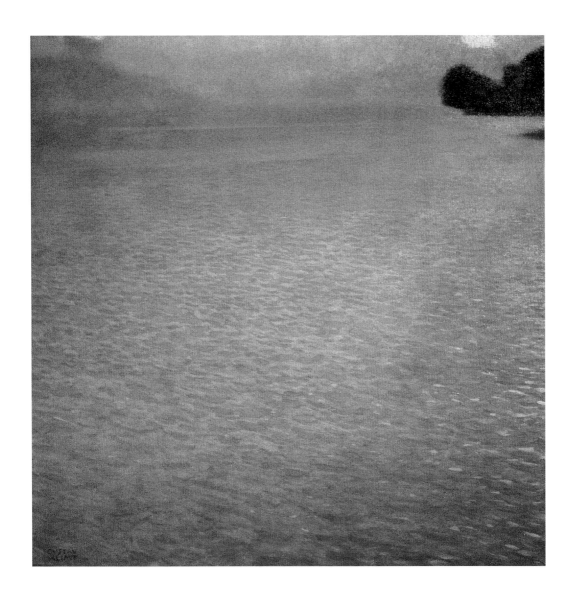

Judith I, 1901

Oil on canvas
84 × 42 cm
Belvedere, Vienna

Here is a Judith as if out of a fashion magazine. This modern woman has very little
to do with the figure from the Old Testament. Slim, with slender limbs, a seductive
gaze and a passionate mouth, appearing unconventional and self-assured, she
embodies a new type of woman with a devastatingly erotic aura. Klimt breaks with
the iconographic tradition of Judith in painting. No sword, no maid, and no basket,
in which, according to the Biblical narrative, the head of Holofernes is laid. As the
Book of Judith reports, Holofernes, the general of the Assyrian king Nebuchadnezzar,
was besieging the town of Bethulia in Judaea. One of the women from the town, the
beautiful, intelligent, wealthy widow Judith, accompanied by her maid, succeeded
by means of a ruse in gaining entry to the Assyrians' camp. Holofernes invited her
into his tent. Judith had brought a basket with powerful wine. When Holofernes was
drunk, she and her maid beheaded him, thereby saving the town.
Klimt only shows the head of the dead man at the bottom right edge of the painting,
as a hint at the Bible story. Only an expert eye will notice a further clue, however: for
the scale ornaments and tree forms in the background, the artist uses as reference an
Assyrian alabaster relief from the palace of Sennacherib which had been in the British
Museum since the middle of the nineteenth century. The half-figure of Judith almost
completely fills the format. She is wearing an elegant transparent wrap with gold
ornaments, which only partially covers the upper body and leaves breast and navel
exposed. Klimt has painted the skin with Impressionist-like brushstrokes and thus
retracts any form of brash physicality. Similarly, he abstracts the precious stones on
her neck choker and belt with casually applied dabs of paint applied impasto. Both
the accessories look two-dimensional; they scarcely follow the form of the body, and
nor do the ornaments on her robe.
Klimt uses the Biblical subject to stage his image of a new type of woman: the
elegant femme fatale, as she was to be found among the haute bourgeoisie of
Vienna. At the same time he revealed his own idea of modern painting. In the golden
age of the Vienna Secession, that included the wooden frame, surmounted by a
broad metal band with the inscription 'JUDITH AND HOLOFERNES'. The repoussé
work was executed by Klimt's brother Georg; thus fine art and crafts are fused here
in a masterly combination.

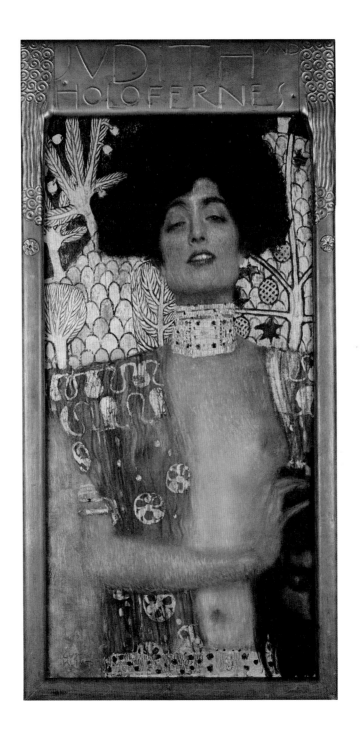

Goldfish, 1901/02

Oil on canvas
181 × 67 cm
Kunstmuseum Solothurn

Outrageous! Klimt had truly overstepped the mark! Obscene, scandalous! Such was
the public opinion when *Goldfish* was exhibited in Vienna for the first time in 1902.
Originally Klimt had planned to call the painting *An meine Kritiker* (To My Critics),
and it was intended as a riposte to the controversy over the Faculty paintings for the
University of Vienna, which Klimt had eventually withdrawn following endless friction
and public dispute. Here he is thumbing his nose at those critics. But that is not the
only reason that they were up in arms. Some of them considered the curvaceous rear
that the saucy red-haired woman is pointing in the viewer's direction to be perverse.
And then there was that smile!

Klimt has packaged his rage in a subject which was preoccupying him particularly at
that time: the underwater world and beguiling mermaids. Four of these mysterious
beings float and hover like waves through their element, cut off by the edges of the
picture and incorporated into the overall structure, which appears to take the form of
a single large ornament. The shocking bodies gleam like mother-of-pearl, so delicate
is the manner in which Klimt has recorded the skin with fine brushstrokes in layers of
nuanced blue, turquoise, violet, yellow and white. Only the fourth, hidden mermaid is
more restrained in her colour scheme. Her long hair coils like the tendrils of water plants,
so that we can imagine how a diver or swimmer would become entangled in it. Vibrant
curving blue lines – it is not quite clear whether they are purely ornamental or belong to
a plant – emphasise the rounded wave movements that characterise the picture. In the
middle of the left-hand group of figures glows an enormous goldfish.

Between the two top mermaids swarms a school of small fish, with golden heads, reddish,
blue and purple bodies and huge dark goggle eyes. Klimt has also scattered a shower of
golden particles that recall shimmering fish scales across the greenish water.

When the picture was sent to the German National Art Exhibition in Düsseldorf, attempts
were made to have it removed before the opening, so as not to offend the German Crown
Prince, who was to open the exhibition. But Klimt had a number of knowledgeable and
eloquent defenders who appreciated the outstanding painterly quality of this work.

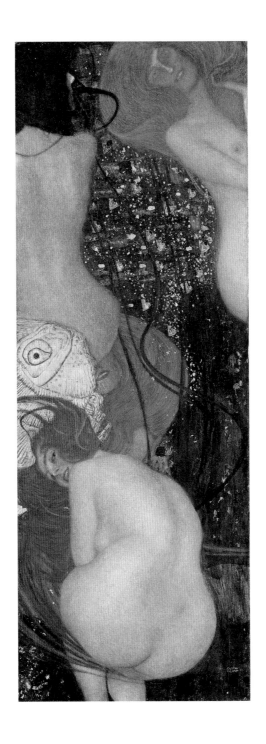

Beethoven Frieze, 1901/02

Casein paints, stucco applications, pencil, various materials (glass, mother of pearl, etc.)
and gold applications on plaster over reed matting
215 × 3414 cm, longitudinal wall, each: 215 × 1392 cm, front wall: 215 × 630 cm
Secession, Vienna (on loan from the Belvedere)

At the 14th exhibition of the Vienna Secession in 1902, the Secessionists created a
Gesamtkunstwerk. The focal point was the Beethoven sculpture of coloured marble,
alabaster, ivory, bronze, amber and gilt by the Leipzig sculptor, painter and graphic
artist Max Klinger. The architecture of the exhibition and all the other works on show
were chosen to complement the sculpture down to the last detail.
Beethoven was regarded as the epitome of the artist who fought against all adverse
circumstances for the salvation of humankind through art. Klimt occupied a prominent
position in the exhibition. He arranged the left-hand side room in the exhibition
building, with which the tour began after passing through the antechambers. Here
visitors were prepared for the Beethoven sculpture, which was already visible through
a gap in the wall. Klimt created an allegorical frieze around the top of the walls by
analogy with Richard Wagner's description of Beethoven's 9th Symphony. As explained
in the catalogue for the exhibition, on the long wall opposite the entrance he painted
'The Yearning for Happiness', 'The Sufferings of Weak Mankind' and the 'Well-Armed
Strong One' (the hero, who takes up the fight on behalf of mankind); on the front
wall, 'The Hostile Forces'; on the second long wall, 'the assuaging of the longing for
happiness' through poetry; and finally, in a kissing scene, salvation. It is based on the
lines 'Joy, beautiful spark of Divinity' and 'This kiss to all the world!' from the *Ode to
Joy* by Friedrich Schiller, which Beethoven set to music in the final movement of his
9th Symphony for Choir and Orchestra.
Klimt symbolises 'the hostile forces' that obstruct the path of man in his striving for
happiness, his fears and cares, through the giant Typhoeus in the form of a huge ape,
his daughters, the three Gorgons – to his left – and behind them 'Disease, Madness,
Death'. To his right are 'Lust and Unchastity, Immoderation', in the middle in front of the
enormous sinuous snake with its scaly ornaments of 'gnawing care' which overwhelms
everything. 'Human longings fly away above them': longings that are embodied by the
hovering figure which appears at top right.
The representation of the universal struggle of the artist in the service of humankind
also had a concrete association for Klimt: the hostility with which he was confronted
after the scandal surrounding the Faculty pictures for the University of Vienna.

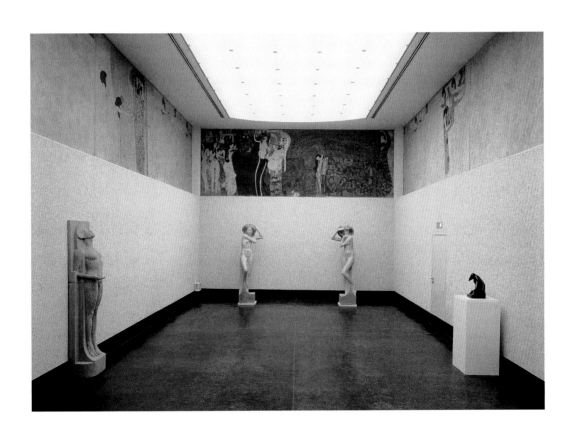

Beech Forest I, c. 1902

Oil on canvas
100 × 100 cm
Staatliche Kunstsammlungen Dresden, Galerie Neue Meister

Gustav Klimt loved nature. He was also a keen sportsman. During his summer holidays with the Flöge family in the Salzkammergut he would go off on hour-long hikes. It was probably during August 1902 that he described his daily routine in a letter to his lover Maria 'Mizzi' Zimmermann in Vienna from Litzlberg, their annual summer residence during the first years at Attersee. He usually got up at 6 am and went into the forest; there, on fine days, he would paint a beech forest in which there were also some conifers. Klimt also described and sketched his viewfinder, for which he had cut a square out of a piece of cardboard. He would hold it in front of his eye and search for motifs in the landscape. Klimt's sister Helene later reported that he would hide his easel in the leaves under the trees, so as not to have to carry it back and forth every day.

This painting is one of a series of forest pictures which Klimt painted between 1901 and 1903 in the vicinity of Litzlberg. It shows a section of forest; we have the impression of being surrounded by trees and looking against the light at the trunks, which are cut off by the upper edge of the picture. Three trunks are also cut off by the lower edge. They serve as a *repoussoir* and create an impression of three-dimensionality which is heightened by the way the trunks taper. The spots of colour that indicate the leaves on the forest floor also become smaller towards the top and thus contribute to the impression of space. If we look more closely at individual parts beneath the horizon, the impression of depth is suspended in a vibrating mass of small brushstrokes. Here Klimt uses the painting technique of Pointillism – as practised by the French artist Paul Signac and the Belgian artist Théo van Rysselberghe, whose pictures were exhibited in the Secession – without, however, adopting the underlying theory of the mixing of pure colours. The tree trunks still lie in the purple shadows of morning, with the dry orange beech leaves in between – complementary colours which mutually intensify their effect. Above, the morning sun shines through the treetops and casts the occasional gold-orange patch of light on the forest floor. The nature mood which Klimt creates here is truly magical. He thus follows in the tradition of Symbolist forest landscapes and at the same time adapts a contemporary painting style for his own approach to landscape painting.

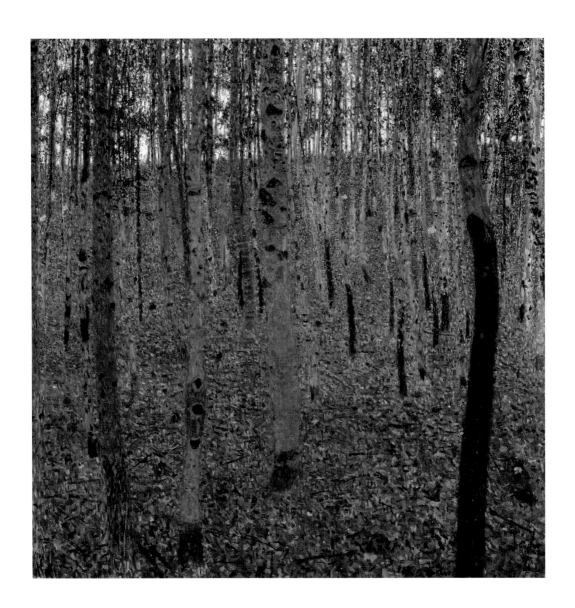

Portrait of Emilie Flöge, 1902/03 (reworked at a later date)

Oil on canvas
181 × 84 cm
Wien Museum, Vienna

Nowadays we would call Emilie Louise Flöge a style icon and trendsetter. Not only her intimate and at the same time liberal partnership with Gustav Klimt, but also her professional and financial independence were unusual for a woman of her time. In 1904 she founded the Modesalon Schwestern Flöge with her sisters Helene and Pauline. She herself took over the artistic direction and made a notable contribution to the spread of the ideas of the Wiener Werkstätte. The shop was designed down to the last detail by Josef Hoffmann and Koloman Moser as a Gesamtkunstwerk. The Flöge sisters not only sold the usual latest fashions to the ladies of the haute bourgeoisie; they also sold designs by Emilie Flöge and Gustav Klimt using fabrics created by the Wiener Werkstätte – full, flowing Reform dresses which allowed the wearer to move freely and which showed off the patterns to best advantage, as well as matching jewellery by Josef Hoffmann and Koloman Moser, muff chains, and necklaces and brooches of silver decorated with semi-precious stones or mother-of-pearl. For almost three decades the Flöge sisters ran one of the top fashion addresses in Vienna.

Emilie Flöge self-confidently gazes directly into the viewer's eyes. Although Klimt began the portrait before the opening of the fashion salon, Emilie, who loved eye-catching clothing, is already wearing a sort of Reform dress. The pattern is reminiscent of a shimmering mosaic. Shades of blue and green dominate the colour scheme, interspersed with gleaming gold and silver. Are the ornaments based on reality or has Klimt allowed his artistic imagination to run riot? The wavy lines, from which spirals branch out like leaf tendrils, emphasise the verticality of the tall narrow format. In addition to the gold and silver elements, the dress is sprinkled with shimmering dots. Emilie's head with its curly hairstyle is framed by a surface with a geometric blossom pattern – perhaps a Japanese leaf fan. It counterbalances the large form in the foreground. Like the entire surroundings, this is only hinted at in a casual manner. On it Klimt positions two square signatures, an artistic device he has borrowed from Japanese art. The squares enliven the surface and correspond in form and colour to the ornaments on the dress. This is one of Klimt's main works and a fascinating portrait of a beautiful, emancipated woman.

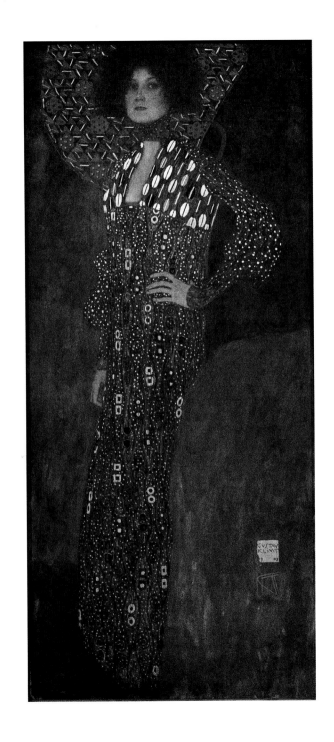

Water Serpents I, 1904–1907

Pencil, watercolours and body colour on parchment, heightened with silver and
gold bronze and gold plating
50 × 20 cm
Belvedere, Vienna

Undines, nereids and mermaids live underwater, in realms where enchanted creatures
float. They drift along on the current between octopuses, serpents and fish. As
the embodiment of unfathomable secrets and seductive eroticism, fanciful female
figures were a popular subject in the art of Symbolism. They occur frequently in
Klimt's oeuvre. Their role models are very earthly, however. For this small format,
which has been meticulously worked down to the smallest detail, the painter drew
a series of preliminary studies after his nude models and tried out a variety of poses
with them.
The picture *Sin* by the Munich 'painter prince' Franz von Stuck may have inspired
Klimt in his design of this picture; the two ultra-slender female figures are obviously
influenced by the painting *Fatalism* by the Dutch Symbolist Jan Toorop, which was
shown in the Vienna Secession in 1901. Their delicate limbs give them an ethereal
air. Light and silent, they appear to hover; the one in front has turned her back
towards the viewer. She has placed her left hand on the body of her partner, and
she in turn has twined her left arm around the other's neck. The elegance of the
two water creatures is reflected in the delicacy of the lines. The entire picture is
permeated with oscillating wave shapes, from the flowing hair to the coils of the
spotted water serpent to the tendrils of the water plants. Spiral forms create an
echo, joined by the widely varying ornaments based on circles and dots as well
as the diamond shapes on the snakeskin. The precious materials – parchment as
the painting support, together with gold and silver – enhance still further the
delicate charm. The carefully coordinated colours culminate in a powerful green
which contrasts with an intense red. Klimt works with body colours as in the
midnight-blue surface, and with translucent watercolours, which he uses to paint
the creature at bottom right, reminiscent of a blobfish, and the octopus arm which
has been sophisticatedly curled into a spiral. Like the coordinated graphic design,
the paint application, the use of gold and silver bronze for the delicately drawn
hair, the plant leaves, the suckers of the octopus and the ornamentation as well as
the gold application in the upper right part of the picture recall the illustrations
of oriental manuscripts. The oakwood frame by the Wiener Werkstätte with its
chased silver mountings is exquisite and matches the luxurious painting.

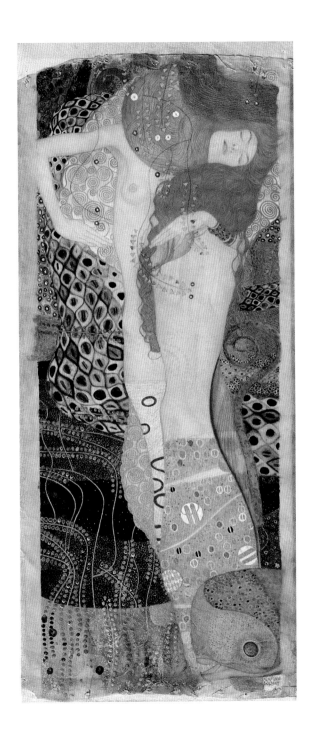

The Three Ages of Woman, 1905

Oil on canvas
180 × 180 cm
Galleria Nazionale d'Arte Moderna e Contemporanea, Rome

Gustav Klimt repeatedly focused his attention on the cycle of life and death. The subject already plays a central role even in the Faculty pictures for the University of Vienna and in the *Beethoven Frieze*. In this painting it is the three female figures who represent humanity. They appear in the centre of the canvas in a band representing life. Our attention focuses first of all on the old woman, whom Klimt has placed on a stripe of shades of red, orange and gold, ornamented with elements representing disease and old age, and interspersed with black and gold horizontal oval shapes. The old woman is shown in profile, thereby emphasising the paunch and the flaccid breasts. Klimt mercilessly models the wrinkled neck, the protruding collar bone, the pointed shoulders, the flabby back, the blood vessels standing out on the work-weary right arm and hand, and the blue veins on legs and feet. Despairing and resigned, the old woman hides her face in her left hand. Her hair is straw-like, pallid, lustreless. She stands there without any firm ground beneath her feet. Beside her is a young woman in the bloom of life. She is holding a little girl in her arms; a blue-pink veil envelops them both. The position of the head and the closed eyes are similar to those that recur in Klimt's allegorical works. As an expression of new life and youth, the long gold-blonde hair is interspersed with little marguerites or daisies and tendrils of leaves, which wind downwards at the side as far as the level of her shins and also entwine the child's legs. The dominant colours in the area surrounding the mother and daughter are cool shades of blue and green, ornamented with triangles and concentric circles. The spiral besides the young woman's left knee can be interpreted as a sign of life.
The luminosity of the group of figures contrasts with the dark background against which Klimt has shown them. The largish area at the bottom and a narrow strip at the top left edge of the picture are modulated in shades of brown, with square shapes hinted at in places. Above them are countless dots which rain downwards in loose rows. At the top, profound darkness yawns – Man must accept his fate, which is death.
The painting earned considerable international recognition and was shown at the 1910 Biennale in Venice, where an entire room was dedicated to the works of Gustav Klimt.

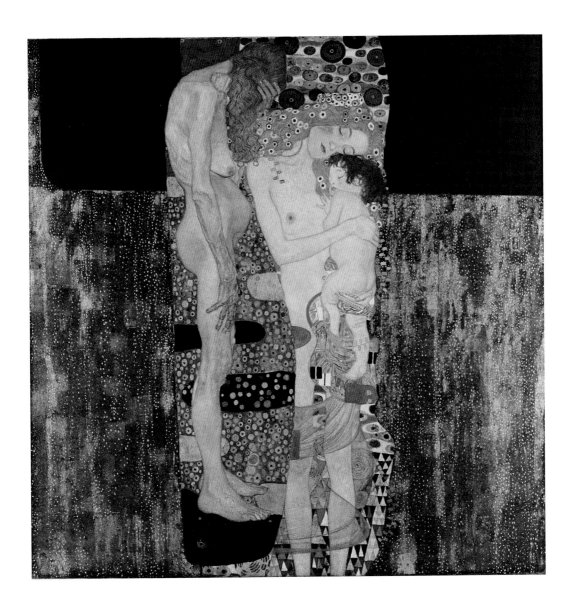

Portrait of Fritza Riedler, 1906

Oil on canvas
153 × 133 cm
Belvedere, Vienna

Serene and slightly reserved, Fritza Riedler gazes at the viewer. Her lips are slightly open and her hands lie relaxed on her lap. Her self-assured pose is reflected in the simple but effective composition of the painting, which is formed by the contrast between the vertical and horizontal rectangles in the left diagonal half of the picture and the light, tranquil triangular form of the figure in the right half. This stands out against the reddish-brown of the background, which is modulated with gentle colour nuances. A dynamism arises through the interplay of regular, articulated areas and large and small geometric forms. Fritza Riedler is sitting in an armchair whose cover is pleated beneath the seat. The pleats have not been worked out in three-dimensional detail and can only be recognised because of the way the pattern of the fabric is offset. Klimt indicates the front edges of the chair arms in a similar manner. As is usually the case in Klimt's portraits from this time onwards, he depicts only the face, arms and hands as possessing volume, together with the frills, ribbons and bows of the white dress which barely models the contours of the body. The ruffles of the silk fabric at the bottom centre of the picture blend into the ornamentation and, in conjunction with the pointed square, establish a connection with the pattern on the armchair cover with the Horus eyes derived from Egyptian art. As in *Portrait of Emilie Flöge* (see pp. 60/61), the head of the sitter is framed by a mosaic-like filled form which is repeated on the right but cut off by the edge of the picture. It is a reference to Diego Velázquez, whom Klimt greatly esteemed. He was able to study the Spanish court painter's portrait from 1652/53 of the Infanta Maria Teresa with her bell-shaped hairstyle surrounding her face in the Kunsthistorisches Museum. In Klimt's painting the pictorial space remains flat; only on the floor do the diamond shapes indicate depth. Here, Klimt uses a gold surface for the first time. He subsequently added the small squares, which appear to hover before the reddish-brown wall in the background.
Friederike Langer, known as Fritza, was born in Berlin in 1860. She married the mechanical engineer from Graz, Aloys Riedler, who taught in Germany from 1880. For the portrait sessions she probably travelled back and forth between Berlin and Vienna, where she and her siblings owned a house. She died in 1927.

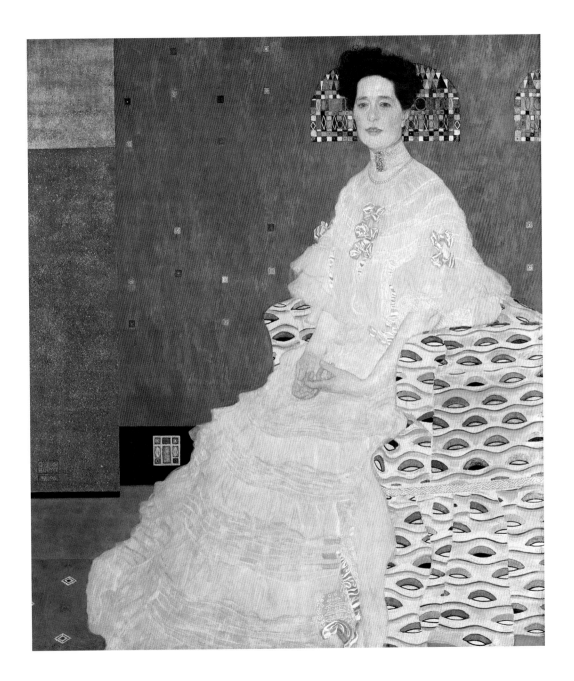

Portrait of Adele Bloch-Bauer I, 1907

Oil, silver and gold on canvas
140 × 140 cm
Neue Galerie New York

In this commissioned portrait, Adele Bloch-Bauer sits enthroned as if framed in a golden shrine. Here, Klimt pulls out all the stops: the work represents the culmination of his 'Golden Phase'. As the son of a gold engraver and the brother of a metal sculptor and chaser, he was familiar with the aesthetics of the metal, which he displays in all its facets. Klimt's visits to Venice and Ravenna with their mosaics bursting with gold tesserae, gold leaf and semi-precious stones had been a revelation. He had travelled to see them twice in 1903 – the year in which he created the first of the many preparatory drawings for the portrait. Only the head and hands of Adele Bloch-Bauer are shown naturalistically, while the body dissolves into a riot of two-dimensional ornamentation. Their variations hint at an armchair and Adele Bloch-Bauer's dress. The décolleté is adorned with rectangles and triangles arranged in bands. Klimt has decorated the centre of the robe with a pattern based on Horus eyes, which look like marquetry. The initials of Adele Bloch-Bauer are woven into some of the squares on the sweeping pleated folds on both sides. The eye-catching narrow black rectangles above the dress incorporate a further spatial level.

Adele Bloch-Bauer was the daughter of the Bauer family, who were bankers. She married Ferdinand Bloch, the owner of a sugar factory, in 1899 at the age of eighteen. He was seventeen years her senior and they both adopted the name Bloch-Bauer. They were patrons of Gustav Klimt and owned six works by him. Their salon was a meeting place for artists, writers and politicians. Their niece Maria Altmann described Adele Bloch-Bauer as elegant, delicate, witty and arrogant, with wide intellectual interests. She died at the age of only forty-three. In her will she requested that her husband leave the Klimt paintings to the Moderne Galerie in Vienna – today the Belvedere. However, in 1938 the Nazis dispossessed Ferdinand Bloch-Bauer, and the pictures ended up illegally in the museum. In 1945 the owner asked in vain for them to be returned, as he no longer regarded himself bound by his wife's request. In his will he determined his brother's children as his heirs. Maria Altmann fought for the return of the works for many years and was finally successful in 2006. The story of the restitution was dramatised in the film *The Woman in Gold*, starring Helen Mirren in the role of the niece. The US-American businessman and art collector Ronald S. Lauder purchased the 'golden Adele' for his museum.

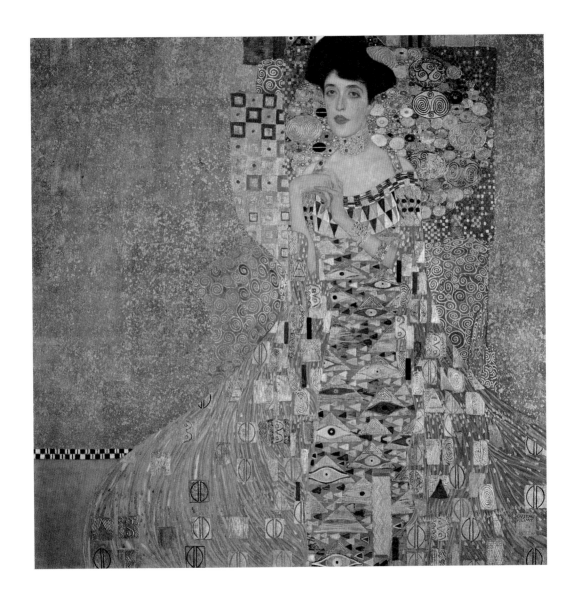

Sunflower (Sunflowers), 1907/08

Oil on canvas
110 × 110 cm
Belvedere, Vienna

A starring role for the sunflower! Women were often compared with flowers, but Klimt seemed to see things the other way round. The painting of the sunflower looks like the portrait of a lady. The artist has placed it in the middle of the picture and brings it up close to the viewer, as he would later do with his collectors' wives from Vienna's haute bourgeoisie. Turned towards the front and facing the viewer, the flower head is depicted in a broad cloak of leaves with a wide border of sunflowers on a narrow strip of green. It reaches almost as far as the top edge of the picture. A wall of densely climbing flowering plants in white and blue, which ends on the ground with a row of pink, short-stemmed sunflowers, increases its magnificence and monumental appearance.

In 1906, during their summer holiday by the Attersee, Klimt took a series of photos of Emilie Flöge in the Reform dresses she had designed. The pictures were intended for a sample catalogue for the fashion salon of the Flöge sisters. Some of them appeared in the magazine *Deutsche Kunst und Dekoration* (German Art and Decoration), published by the Darmstadt publisher Alexander Koch, who played an important part in the founding of the artists' colony on the Mathildenhöhe in Darmstadt in 1899. The location where the photos were shot was the cottage garden of Anton Mayr in the immediate vicinity of the Bräuhof in Litzlberg, where Klimt and the Flöge family stayed for their holidays between 1900 and 1907. The comparison between the painting and the photos of Klimt's friend in her flowing, loosely-fitting clothes is striking. Evidently the photography inspired the artist to present the sunflower in an anthropomorphic manner.

Klimt develops new possibilities of composition and spatial effect here. The thicket of plants in the background is close to the viewer and blocks the view into the depths, all the more because Klimt has applied the paint – as in the picture as a whole – opaquely and with brushstrokes layered one on top of the other. The impenetrable wall of vegetation makes the sunflower stand out and lends it a monumental quality. The brushwork remains clearly visible. The powerful, long, light-blue strokes of colour in the large heart-shaped leaves of the sunflower catch our eye, while the brushwork in the background is detailed and allows the green to flicker. These effects, which tend towards abstraction, can be observed in bright sunlight in real life. In Klimt's artwork, they help to divert our gaze from the representational to the painterly and the effect of colour.

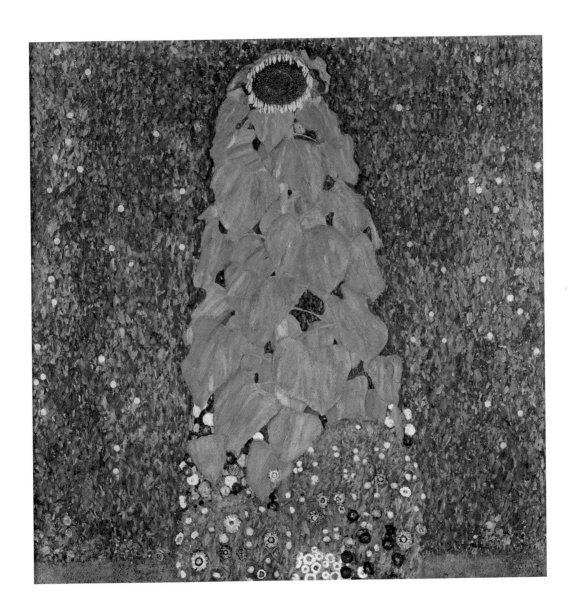

Hope II (Vision), 1907/08

Oil, silver and gold on canvas
110.5 × 110.5 cm
The Museum of Modern Art, New York

Representations of pregnant women are rare in the history of painting, but they frequently occur in the oeuvre of Gustav Klimt. Apart from his personal experience – Klimt was the father of at least six children – the pregnant woman was an important subject for him because embodying the expectation of new life and signifying the ever-recurring new beginning in the eternal cycle of growth and decay. With the skull above the woman's belly the painter hints at the fact that even this new life is doomed to die, and is also at risk of being extinguished again all too soon. In Klimt's time, child mortality was still high. In 1903 the artist had to endure the death of his second son, Otto, from his relationship with his long-standing model Maria 'Mizzi' Zimmermann, at the age of just two months. As a result of this experience, he painted a skull retrospectively above the head of the nude pregnant woman in *Hope I*, for which his lover probably acted as model. Has the expectant mother here lowered her head and closed her eyes in awareness of the possible threat? Her facial features appear exhausted and haggard. Are the three women at her feet begging with their hands raised that the birth will take place safely and the child will grow up healthy? Is the pregnant woman simply listening to the new life in her womb and feeling the child's movements? Klimt called the painting *Vision* when it was first shown at the International Art Exhibition in Vienna in 1909. What sort of premonition was he referring to? Between 1909 and 1914, however, the painter also changed another important detail: he painted over the halo which had previously surrounded the pregnant woman's head, and only then added the skull.
Gleaming areas of gold and silver and extensive ornamentation in intense colours adorn the pregnant woman's gown, which envelops her like a voluminous coat. They do not follow the silhouette of the body, so that the figure appears flat except for the upper body, face and hands. It remains in a single plane with the background, which also surrounds her and which Klimt adorned with gold and silver embedded particles. Klimt had discovered the technique of applying gold in Japanese art, which had influenced European artists profoundly since the end of the nineteenth century. He owned specialist literature on the subject as well as a collection of Japanese art objects and kimonos.

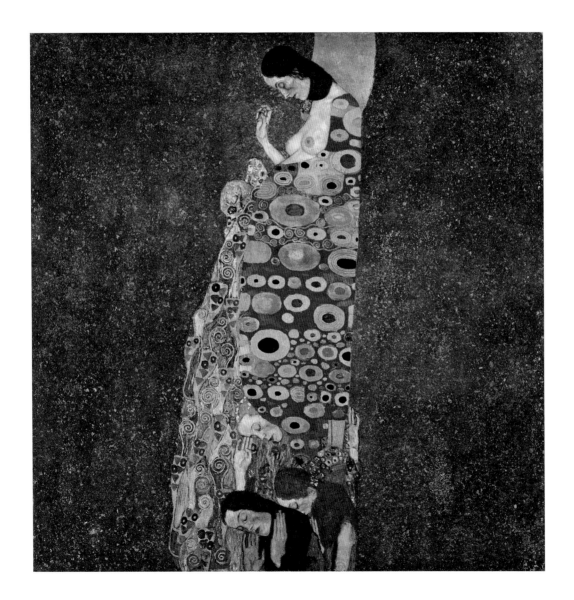

The Kiss (The Lovers), 1907/08

Oil, gold, silver, lead and platinum plating, and schlag leaf on canvas
180 × 180 cm
Belvedere, Vienna

Is it they, or not? Some Klimt experts believe that here the artist has portrayed himself with Emilie Flöge. However, it is by no means certain, especially as the man's features are almost unrecognisable because of the masterly foreshortening of the head. *The Kiss* is probably Klimt's most famous work. When the artist presented the painting in its nearly finished state at the Kunstschau Wien (Vienna Art Show) in 1908, he received both effusive praise and vitriolic criticism from the public. Regardless of the voices of disapproval, the Ministry of Education nonetheless acquired the picture for the Moderne Galerie even before the exhibition was over, together with several of Klimt's portraits of ladies. It still hangs there today. The purchase may have been by way of compensation for the failure of the commission for the Faculty paintings in the University of Vienna.

Klimt repeatedly focused his attention on the physical and mental union of man and woman. A similar pair of lovers fused into a single silhouette can be found in the wall decorations for the Palais Stoclet and even earlier in the *Beethoven Frieze*. There, as here, it is framed by an aureole which unites the two bodies even more closely. They can be distinguished by the ornamentation on their clothing. The man's robe is decorated with narrow rectangles in black, gold and silver, while the woman's gown is adorned with colourful, blossom-like ovals and wavy lines. The cut and patterns recall the clothing made by the Flöge sisters using fabrics from the Wiener Werkstätte, for which Klimt had also supplied designs. While hands and faces, the nape of the man's neck and the woman's limbs are worked out three-dimensionally with light and dark hues, the ornamentation does not follow the forms of the bodies. The overall picture structure is two-dimensional. The background is also spatially indeterminate, a shimmering surface on which golden dots twinkle like stars. Here Klimt has covered the canvas with bronze schlag leaf, to which he has then applied a coloured glaze. Nor does the flowered meadow show much depth; it looks like a carpet of blossoms spread out across the picture surface. The golden tendrils, which seem to dissolve above it in the gold, enhance this effect and blur with the flowers to form an almost abstract composition.

Might Paradise look like this? The 'Ver sacrum', the 'sacred spring' of the Vienna Secession, which brings aesthetic salvation?

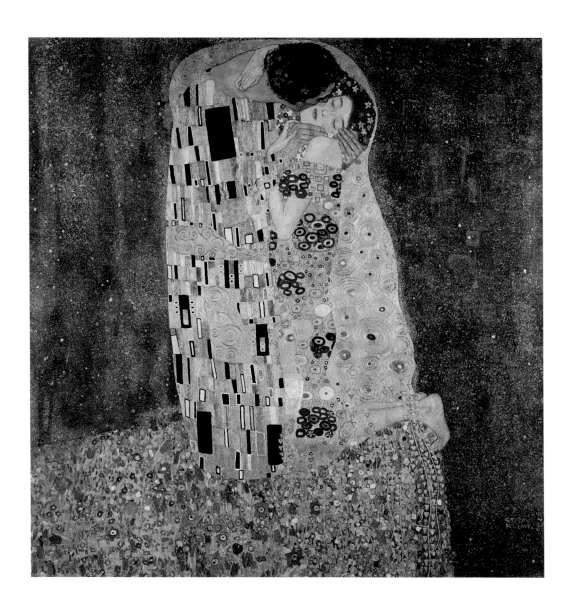

The Park, 1909

Oil on canvas
110.4 × 110.4 cm
The Museum of Modern Art, New York

The canvas is covered with flickering green, composed of countless spots of colour. Light green, dark green, yellowish-green, bluish-green, violet, blue, bluish-grey, light blue, pink, yellow… In between, the light canvas shines through. Sometimes Klimt's brush has been placed vertically, sometimes slightly shifted to the left or right or occasionally diagonally, thereby heightening still further the flickering effect of the dots of colour. This technique recalls that of the Pointillists, who positioned tiny dots of pure colour side by side on the basis of scientific knowledge of the chromatic fragmentation of light. When viewed from a distance, the dots combine visually to produce mixed colours. Klimt was aiming to achieve the effect of a mosaic with his dot-like application of paint. His experience from his work on the *Stoclet Frieze* played an important role; there, he was taking full advantage of the decorative effect of the materials: the glistening of the gold and silver mosaic, and of semi-precious stones, mother-of-pearl and enamel. It was a decorative effect which he now aimed at with oil paint and which here reaches a high point in his painting.

Almost the entire format has been filled out in this manner, with the exception of a narrow strip at the bottom. Here the green has been anchored in representationalism and made comprehensible as the foliage of mighty trees. But the clearly recognisable tree trunks in the foreground, which in places rise up into the vibrating green surface, also oscillate between a naturalistic depiction and the abstraction of pure painting. The spots on the bark develop a life of their own and mediate between the coloured dots and the white parts which hint at the sky and open up the scene into the depths. A dark hedge, for which Klimt places the brushstrokes horizontally, extends on the right in front of a light-green stripe where the sunlight seems to fall between the trees. The entire painting is determined by the relationship of tension between representationalism and painterly form, between the observed depth of reality and the emphasis of the pictorial surface. Here Klimt arrives at the highest degree of abstraction in his work.

The place which inspired Klimt to this unusual landscape painting is the park of Schloss Kammer at Attersee. It was here that the artist frequently spent his summer holidays, both for recreation and in order to develop his concept of landscape painting, which oscillates between space and plane, between a feeling for nature and compositional form.

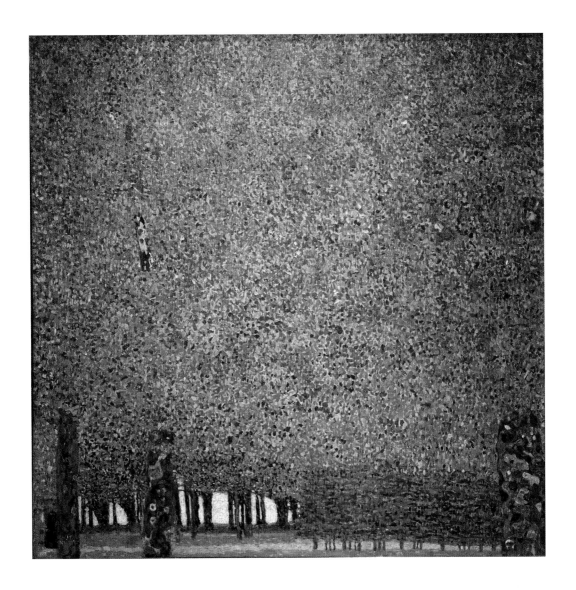

Semi-Nude Lying on Her Stomach, 1910

Pencil and blue and red crayon on Japan paper
37 × 56.3 cm
Private collection

For Klimt, drawing women was an obsession. In addition to a large number of portrait studies and composition sketches of Vienna's society ladies, he also created countless erotic sheets. He always had several models in his studio, and every day, in addition to his work on his portraits, he would draw them in a wide variety of poses, dressed, half-dressed or as nudes. The reclining woman who appears to be hovering was a recurring motif. Here Klimt can be seen concentrating on the outline. In his drawings, contours became increasingly freely drawn as he confidently and playfully explored the field of tension between volumes and surface, between the drawing and the paper and background. His treatment of the line was revolutionary and led the way for the younger artists Egon Schiele and Oskar Kokoschka.

The female figure flows diagonally across the sheet; her hitched-up gown that covers her lower legs swirls around her. The folds and patterns of the fabric emphasise her nudity, which she displays openly and provocatively to the viewer's gaze. The variety of the linework is overwhelming. Precise, pulsating colours in black and red create the volumes of the body forms in masterly fashion, without the need for Klimt to use assisting grey shading. When he searches for the line and repositions it, as on the elbow on the right, the first lines remain. The interplay with the corrections bestows a particular charm on the drawing. A free interplay of lines – curves, whorls and loops – is revealed in the puffy folds of the fabric. Klimt describes the woman's hairstyle with lightly flowing contours; then he fills the outline with a confusion of blue lines to indicate the mass of curls. White lines are added on a further graphic layer and lend the fabric more volume and airiness.

Klimt underlines the woman's pudenda in red. This serves as counterpoint to the dark eyes beneath the powerful eyebrows, whose lascivious gaze is directed dreamily sideways into emptiness, and the red painted lips. Klimt also accents with red the model's bracelets and hair as well as the folds and ornamentation on the fabric. Although the couch on which she is lying has not been indicated, we nonetheless have the impression we can perceive its presence. Thus Klimt creates a balanced equilibrium of a figure that is half-lying and half-hovering.

Lady with Hat and Feather Boa, c. 1910

Oil on canvas
69 × 55 cm
Private collection

This painting radiates Parisian flair. It looks less like a posed portrait than a street scene with an elegantly dressed lady late at night in front of a theatre or restaurant whose coloured lights are flashing in the background. Her half-closed eyes are glancing sideways, and her chin and lower lip are hidden behind her feather boa. What is unusual for Klimt is the dark overall mood, out of which the sparingly placed intense colours as well as the lady's pale face and white blouse or dress glow, although the rest of her form otherwise scarcely stands out.

Not only the subject exudes Parisian flair. The painting, too, seems to imply French influence. Under the impression of the heightened colours of the Fauves, and specifically the pictures of Henri Matisse, Klimt increasingly dissolved the rigorously structured ornamentation and experimented with colour and brushwork. The canvas is relatively small and the figure shown only as a bust. Perhaps this intimate, understated format permitted an extremely specific ease of brushwork and paint application.

With short, broad strokes Klimt designed the background, and hinted within it at red, green, yellow and white shapes with rapid momentum. The pattern on the white breast section has been sketchily noted in zigzag lines. The brushwork of the feather boa hints at its material texture. Klimt portrays the curly hair with a multitude of small coloured strokes that cross over each other in shades of reddish brown, red and yellow ochre as well as greenish-blue for the shadows. The towering arrangement of the hat corresponds to contemporary fashion, with straight lines, wavy lines and curves in deep bluish-violet. The hat brim consists of parallel brushstrokes in nuances of the same shade of colour. The mysterious bluish-violet determines the seductive mood of the picture. It forms an excellent contrast with the reddish-blonde hair of the wearer. Both colours enhance the intensity of the other.

For a long time, the painting was thought to be a portrait of Emilie Flöge. Probably, however, one of Klimt's numerous unknown models posed for it. Nor does the scene take place in the nightlife of Paris. When the painting was being restored in 1994/95, not only was the violet of the hat restored to its former brilliance but it was also discovered that behind the lady's head Klimt had hinted not at coloured lights but at Asian objects within a shelf.

Seated Woman from the Front with Hat, Face Hooded, 1910

Graphite, with coloured pencil, on ivory wove paper
55.7 × 37.2 cm
The Art Institute of Chicago

Klimt's models were available in his studio all day long. Evidently he had intimate relationships with them. He watched and drew the young women in their most private moments, in situations of lust which they created for themselves by masturbating. He fathered a total of six children with three of them: Maria 'Mizzi' Zimmermann, Maria Učická and Consuela Camilla Huber.

Klimt shows the women enraptured and dreamy, absent and concentrating on themselves and their lust. Here we cannot even see the model's face; her hat shields her from the viewer. She is completely absorbed. She is evidently wearing street clothes which contrast with her intimate occupation and increase the sex appeal. Her black stockinged legs are wide apart and direct the viewer's gaze to her genitals between the frills of her underwear, which Klimt sketches with playful white and black lines.

Klimt's drawings of masturbating women were influenced by Japanese shunga prints or 'spring pictures': woodcuts that depicted explicit sexual situations. The protagonists wore gowns in magnificent patterns and colours that blatantly revealed the male and female genitals and the sex act. They became available in Europe from the end of the eighteenth century on, and Klimt owned an album of shunga prints.

Explicit depictions of female genitals at that time were taboo. In 1866, commissioned by a Turkish-Egyptian diplomat in Paris, the French artist Gustave Courbet painted *L'origine du monde* (The Origin of the World), an anatomically precise representation of the genitals between the outspread legs of a woman. Only the owner's selected guests were permitted to see the picture. Klimt did not exhibit his erotic drawings. In 1905 he made a selection of fifteen sheets from the years 1904 to 1905 available as illustrations for an edition of the *Dialogues of the Courtesans* by Lucian.

The French sculptor Auguste Rodin, a corresponding member of the Vienna Secession, also drew masturbating women. He travelled to Vienna in 1902 and partook in a lively meal with Klimt, the Secessionists and some beautiful women in the Prater. Rodin admired Klimt's drawings. It would be hard to exaggerate the latter's importance as a graphic artist. For a long time his fame was based primarily on his drawing skills.

Death and Life, 1910/11, reworked 1915/16

Oil on canvas
180.5 × 200.5 cm
Leopold Museum, Vienna

Throughout his life, Gustav Klimt remained true to his love of ornamentation. Even Death wears a robe with a pattern that could have been designed in the Wiener Werkstätte. In a sophisticated interplay of figure and background, mainly black bar-shaped crosses are woven into the fabric – crosses on rectangular patches in deep vibrant green, blue and violet heightened with white contours, and others that lie in the gaps between the rectangles, overlapping them in places.

Death is standing opposite the fullness of life – three ages in a stream of bodies that combine to create an oval shape contrasting sharply with the background. Firstly, it is a celebration of youth. Beautiful young women, draped only partially in patterned fabrics aglow with flowers and geometric shapes, recline or stand in front of a rose bush covered with flowers, geometrically executed in green triangles and circles in shades between red and white. Klimt has depicted the shimmering skin using delicate pastel tones. With rosy cheeks and closed eyes, they cuddle up together as if dreaming and ignoring Death, who raises a club instead of his scythe. The young mother of the rosy pink infant smiles blissfully as the child kicks out with his plump little legs. To the left of mother and son, one woman is gazing with wide-open eyes – a hint at the awareness of death, which is the destiny of all living things from the moment of their birth? Does this knowledge also afflict the couple in the foreground? The vigorous man, muscular and tanned, embraces his partner protectively. She has placed her left hand and her head on his right arm as if in grief. Between the two groups is an old woman. Her face is sunken, her thin grey hair covered with a bonnet as she bends her head forward in resignation.

Klimt worked on this painting for some years. He prepared it with sketches as early as 1908. In the first version, which was shown in Rome in 1911, Death has a golden halo and is looking downwards, his head half-covered. The background is reddish-brown, possibly also planned as gold; the group of figures is smaller, and the ornaments are less lavish. Klimt added the club at a later date. We can trace his artistic development in the way he reworked the painting. He evidently regarded the picture – one of his main works – as very important, because he sent it to numerous exhibitions throughout Europe.

Expectation (Dancer), design cartoon for the Stoclet Frieze, 1911

Gouache, pastels, gold, platinum, silver and bronze on tracing paper
200 × 102 cm
MAK, Vienna

For the dining room of the city palace of Adolphe Stoclet and his wife Suzanne in Brussels, which was built by Josef Hoffmann, Klimt created a magic garden in the form of a three-part frieze. It was a further development of the *Beethoven Frieze* in the Vienna Secession building. This time, however, Klimt did not need to bear the costs in mind, but could realise fully his ideas for a collage that would determine the character of the room – made of gold and silver mosaic, chased gold, mother-of-pearl and semi-precious stones, enamel and glazed ceramic, and embedded in marble. He drew the cartoons during his summer sojourn with the Flöges in Kammerl on the Attersee. On the tracing cartoons he gave precise instructions for the execution, which was taken over by the metalworking and goldsmiths' workshop of the Wiener Werkstätte together with the mosaic workshop of Leopold Forster, the ceramics workshop of Bertold Löffler and the enamel artists of the Vienna College of Applied Arts: '4th PART – FROM – LEFT / Some sort of white material, slightly raised and smooth very / white – not mosaic / not mosaic but some sort of very white material smooth / and raised / The circles drawn on the trunk in pencil in gold are / (to be applied in gold) in slightly roughened metal / specks mosaic / gold mosaic / green mosaic / mosaic / the patches shown with light silver are (possibly) to be inserted in mother-of-pearl […].'
The basic motif is a flowery meadow with, in each of the long sides, the 'Tree of Life' in the middle. The twigs, on which Horus birds are perched, spread out on both sides across the entire surface except for the bottom strip with the flowery meadow and the white ground. They are formed like spirals, a symbol frequently used by Klimt to represent life. The beginning of each long side is marked by two stylised rose bushes. To the right of the entrance the representation of the main subject concludes with a female dancer entitled *Expectation,* with echoes of both Egypt and Japan. Opposite her, on the long side to the left, is *Fulfilment,* an embracing couple that recalls the lovers in the concluding scene of the *Beethoven Frieze.* In the middle of the short side, between the entrance doors, is a knight who is dissolved into abstract forms. The frieze represents the culmination of Klimt's ornamental development, at a time when he was already embarking on new approaches under the impression of the painting of El Greco.

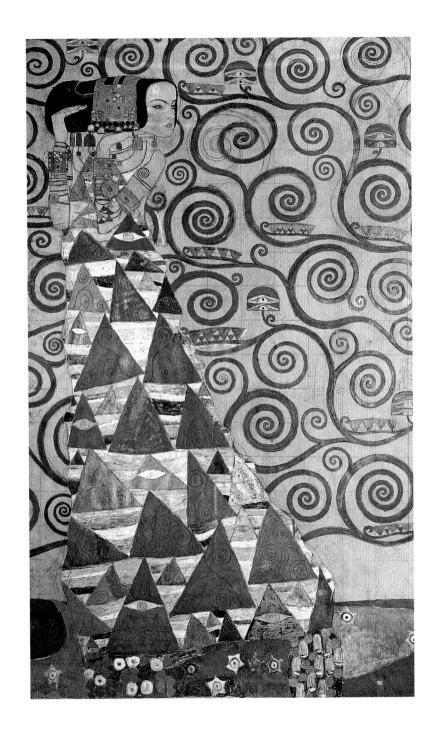

The Avenue in Schloss Kammer Park, 1912

Oil on canvas
110 × 110 cm
Belvedere, Vienna

Between 1908 and 1912 Klimt stayed with the Flöges in Kammerl, a district of Kammern on the northeastern shore of the Attersee, during their summer holidays at the lake. Schloss Kammer, a former moated castle, lies on a peninsula in the lake. It was originally linked with the shore only by a jetty, but during the eighteenth century a causeway was constructed and planted with trees. Klimt painted the palace on several occasions. As a subject, the avenue posed a considerable challenge with regard to the relationship of tension between space and plane which interested him so profoundly. Here, he does not position the two rows of trees leading into the distance on a symmetrical axis; rather, in the interests of a dynamic picture structure, he places them well to one side of the centre. This means that the palace building, towards which the avenue leads, does not lie in the dead centre of the composition. Moreover, the light section of the lake gleaming between the tree trunks at the bottom left edge of the picture acts as a counterbalance and corresponds with the small patch of sky above the palace roof. In addition to these delicate shades of blue, the background is characterised above all by subtle yellow, light red and pink as well as fresh shades of green, allowing these to come to the fore and contrast with the depth perspective of the avenue, in order to combine the various pictorial elements in the planar composition. The approach to the palace twinkles in variations of yellowish-pink, blue and green.

The main part of the picture is filled by the treetops of the trees bordering the avenue. Klimt has composed their foliage with blue, yellow and green dabs of colour. They fuse together to create a shimmering green surface. The painter also scales back the volume of the trunks and branches by giving them dark contours, unlike in his previous paintings of Schloss Kammer. He may have been influenced here by French Cloisonnism or by Vincent van Gogh. The expressive colours of the bark, executed with powerful brushstrokes in shades of blue, blue-green, yellow-green and pink, fit in with this concept. Klimt was familiar with the French art scene through exhibitions in the Vienna Secession as well as a sojourn in Paris in October 1909 on his way to Spain. However, no comments by him regarding his impressions on that occasion have survived, except that he 'painted a vast amount' while he was there. In this painting Klimt has created another work in which nature observation and abstract form-finding are perfectly balanced.

Portrait of Adele Bloch-Bauer II, 1912

Oil on canvas
190 × 120 cm
Private collection

What a difference! The same woman (see pp. 68/69), but a different painting style. Tall format instead of a square. Standing on a rug instead of sitting in an armchair. A close-fitting dress with a sash, a fur-lined stole and a large hat instead of a loose pleated robe. Seen from the front instead of a three-quarter profile. Blossoms and Asian figures instead of rectangles and squares. And especially: luxuriant colours instead of gold. Five years separated the 'golden' and the 'colourful' Adele. Gustav Klimt had developed his painting still further. In 1909 he was one of the organisers of the International Art Exhibition in Vienna with works by artists including Vincent van Gogh and Henri Matisse. The latter loved fabrics, wallpaper and carpets with bold patterns. They appear in his paintings in interaction with figures and objects which he dissolved into brilliantly coloured surfaces and contrasted with each other. That same year, during his journey via Paris to Spain, Klimt was also impressed by the expressive colours of El Greco.

Although similar colours had already occurred in Klimt's landscapes, in his portraits they were new. New, too, and seen in this particular work, is the almost symmetrical pictorial structure and the division of the space surrounding the figure into clearly separate areas. Adele Bloch-Bauer has moved almost imperceptibly from the centre of the picture to the right; the green in the background with the inserted form in a lighter shade of green is broader on the right than on the left, and the pink-coloured stripe on that side is correspondingly narrower. The sophisticated shift and the lively brushwork lighten the composition. The casually strewn blossoms, which hint at a carpet in spatial perspective on the floor and become blurred in the middle and at the sides, serve to introduce dynamism into the picture. In the upper red area, Asian figures romp. Klimt owned Chinese artworks and gowns, in which he found references for them. The dark oval of the hat stands out in stark contrast to the background. The head and hands of the model and also the bodice of the dress are painted naturalistically in the accustomed Klimt manner; towards the hem, the skirt blurs into its surroundings.

This portrait was also extorted from Ferdinand Bloch-Bauer by the Nazis and was returned to the heirs in 2006. The American talk show hostess and media business-woman Oprah Winfrey acquired it in an auction a short while later for 87.9 million dollars. Ten years later she sold it for 150 million to an unknown collector from China.

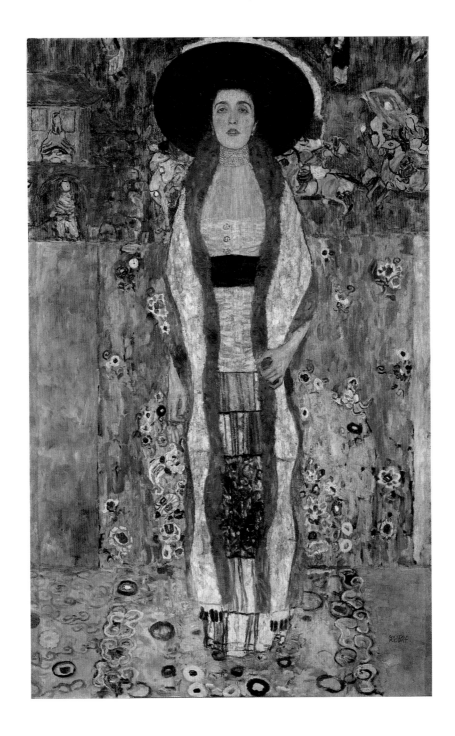

Mäda Primavesi, c. 1912/13

Oil on canvas
149.9 × 110.5 cm
The Metropolitan Museum of Art, New York

Doesn't she look almost a little cheeky, with her great eyes gazing intelligently and without a trace of shyness directly at the viewer? Mäda was nine years old when she sat for Gustav Klimt. With childlike determination, her hands behind her back, she is standing at the front edge of the picture with her feet firmly on the ground, occupying the entire height of the format. This representation of a child as a full-length life-size figure is unusual in Klimt's oeuvre.

Mäda Primavesi was the eldest daughter of Otto Primavesi, a banker and businessman from Olomouc, and his wife Eugenia. The couple had long admired the artist before commissioning the portrait. Not long afterwards, Eugenia Primavesi also sat for a portrait by Klimt that she intended to give her husband for Christmas.

Klimt prepared Mäda's portrait with numerous pencil sketches and experimented with a variety of poses. In his portraits of women the feet are usually hidden, but here they form an important element in the composition. The hands, by contrast, are not visible, although in Klimt's likenesses of adult models their position and execution often play major roles. As in most of his portraits, Klimt has created the face in the greatest detail, while permitting himself more artistic freedom in depicting Mäda's clothing. The room in which he places her – or rather, the room in front of which he positions her – is cheerful and lively. The impression of depth in the perspectival lines that divide up the carpet contrast with the two-dimensional use of the colours and ornaments in the background. The trio of zigzag lines at the bottom are blithely dashed off with vigorous strokes without any sense of perspective. Their informal appearance corresponds to the casual description of the bow in Mäda's hair. Against the light background of the floor behind her, representational motifs have been distributed: grass, leaf tendrils, birds, a dog, a fish... To the left and right are roses which dissolve into abstract colourful whorls and correspond with the floral decoration on Mäda's dress. Across the pink wall composed of juxtaposed and superimposed blue, green, violet and pink brushstrokes, tiny flowers hover like butterflies. Much later, in old age, Mäda Primavesi remembered how kind Professor Klimt had been to her, even though she had sometimes become impatient while she was sitting for him.

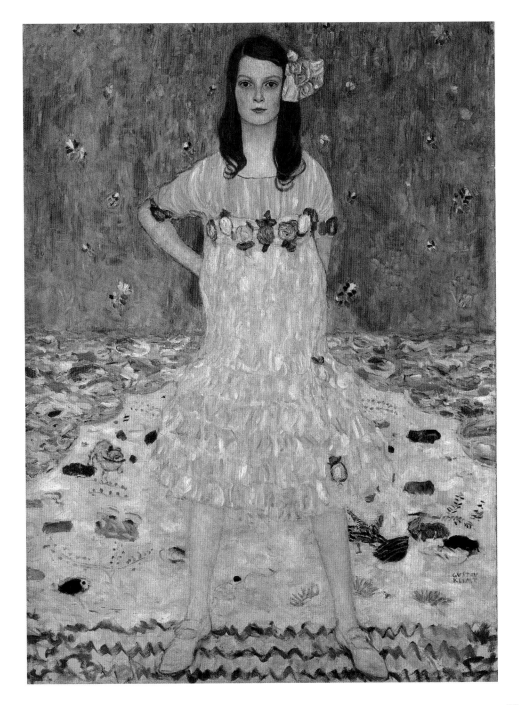

Forester's House in Weissenbach I (Country House at Attersee), 1914

Oil on canvas
110 × 110 cm
Belvedere, Vienna (on loan from a private collection)

The epitome of a summer holiday! That is the impression we gain from this painting. And it really was the significance for Klimt of the forester's house at the entrance to the Weissenbach valley. There, situated a short distance inland from the southeastern end of the Attersee, he found a place of peace where he could rest and work during the summers between 1914 and 1916. The Flöge family stayed about a kilometre away in the village of Weissenbach, directly on the lake. Nevertheless, Klimt and Emilie saw each other every day, went hiking together and received friends together.

In the meantime, Klimt had started to use binoculars or opera glasses for the selection of his landscape motifs. This helped him to narrow down and concentrate the picture detail. In this way he could also create a certain distance to the representationalism of his subjects, especially because he could bring them closer and thus remove them from their real context. The composition is divided into horizontal zones parallel to the picture, whereby sections that are distinguished by small details alternate with calmer sections. They are not stacked one behind the other but are superimposed and linked together by the ovals of the bushes. Even the two cut-off shrubs to the right and left frame the flowered meadow rather than leading our gaze into the depths of the picture. Spatiality is created at best by the proportions, because in our perception smaller objects are understood as being farther away. The house, the bushes – everything seems flat; even the summer meadow with poppies, marguerites and bellflowers rises up like a wall and recalls the ornamentation in Klimt's portraits. A wavy strip of light swirls around the forester's house in light green. In detail the entire painting consists of a multitude of tiny individual brushstrokes; the only exceptions are the flowers and the white parts of the house. The grass, the bushes, the green creepers growing up the building, the meadow in front of and behind the house and the adjacent forest are distinguished from each other mainly by the choice of different shades of green, into which, here and there, Klimt introduces grey-blue, yellow and white. The drawing of the shingle roof is notable. Klimt has distributed countless tiny coloured brushstrokes across the accurate lines of the individual roof tiles.

On 28 July 1914, the summer holiday was disrupted by Austria-Hungary's declaration of war on Serbia. Klimt was annoyed that the newspapers were immediately sold out and he was no longer able to buy copies.

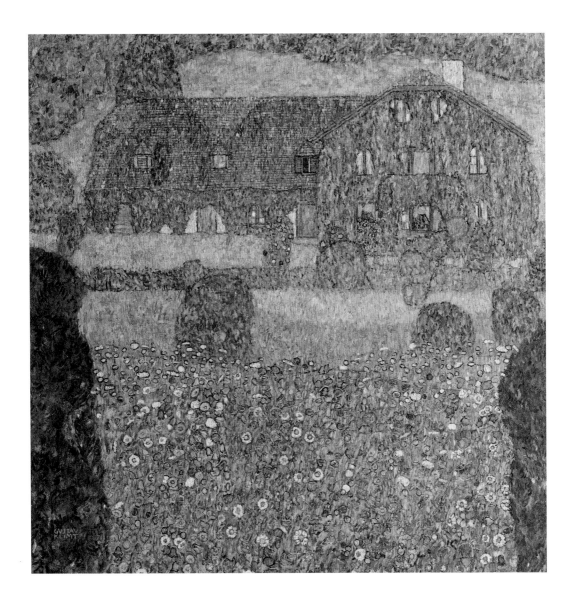

Church in Unterach on Attersee, 1915/16

Oil on canvas
110 × 110 cm
Private collection

By 1915, the situation in Vienna was deteriorating rapidly. The first ration cards for bread and flour were distributed in April. It became difficult to travel out into the countryside without official permission. Austria-Hungary fought a succession of battles with heavy losses against the Kingdom of Italy by the river Isonzo (Soča). In 1916 the Entente and the Central Powers were caught up in ten months of continuous fighting in Verdun which resulted in hundreds of thousands of deaths. Klimt was not among the artists who were full of enthusiasm for the war that had begun in 1914, and he continued singlemindedly with his work. He painted the idyll at Attersee in the midst of war.

Klimt liked swimming and rowing, and it is said that he would take his canvases with him on the boat, whatever the weather, as many of his landscapes look as if they were composed from the water. However, his opera glasses and binoculars permitted him to gain a close-up view of the subjects on the opposite shore. The fact that the structure of this picture is based on a detail view which Klimt selected specifically speaks for this procedure. Mostly he determined the main features of form and colour during his summer holiday, and then completed the pictures back at home in his studio. He frequently used postcards and photographs as an aid to memory.

The painting has been composed two-dimensionally. Klimt combines details to create larger forms, which he then sometimes fills out evenly with broad, powerful brushstrokes. The blocks of the buildings are relieved by little rectangles and curved forms which hint at the chimneys, windows and doors. The contrast between light and dark and the complementary colours of green and red determine the colour scheme. The strong contrasts, the dark contour lines of the individual picture elements and the overlapping roof shapes recall Egon Schiele's pictures of the little town of Krumau (Český Krumlov) in southern Bohemia. Klimt provided encouragement for the younger artist, who was also a personal friend.

As a modulation of the main colour themes, shades of blue have been added alongside variations of yellow, brown, pink and violet in the group of little houses on the right and their reflections in the water. The colours in the picture are echoed faintly in the depiction of the surface of the water, whereby Klimt departs from reality in the interests of his composition: the water surface consists of a series of broad stripes of different widths, whose rhythm and colour are determined less by the subject than by the logic of the picture structure.

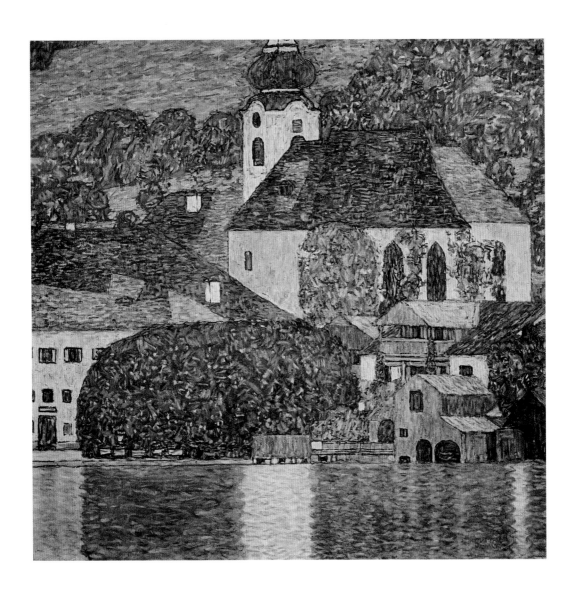

Portrait of Friederike Maria Beer, 1916

Oil on canvas
168 × 130 cm
Tel Aviv Museum of Art

You could describe Friederike Maria Beer as a living advertisement for the Wiener Werkstätte. She wore almost exclusively clothes made from fabrics that had been designed there. This is one created using the pongee silk 'Marina' designed by Dagobert Peche, with a wave pattern full of contrasts. In 1964 Friederike Maria Beer gave the dress to the Metropolitan Museum of Art in New York. The jacket is equally extravagant: a polecat fur lined with 'Flora' silk by Leo Blonder. Klimt is said to have previously tried out various items of Chinese and Japanese clothing from his own stock as the gown for the portrait. Friederike Maria Beer was to wear her new fur coat, of which she was very proud, inside-out so that the magnificent silk lining could be shown off to best advantage. For the background Klimt used motifs from East Asia, magnified many times – according to Beer, taken from the decoration on a Korean vase. Klimt used them so extravagantly that the subject became fused with her surroundings, especially as the heads of the motif figures are almost as large as her own. The picture is a riot of patterns and colours which is held together by the calmer zone of the floor.

Friederike Maria Beer was self-confident, headstrong and interested in art. The portrait was a gift from her friend, the painter Hans Böhler, who came from a family of industrialists. Beer had known Böhler since her childhood, and in 1908, when she was seventeen, he had painted a nude portrait of her. In 1915 she asked for a portrait by Gustav Klimt as a present from him instead of a pearl necklace. Egon Schiele had already painted her portrait in 1914. Her wish to have her portrait painted by Oskar Kokoschka also could not be fulfilled because of the First World War.

The portrait sittings with Klimt were long and tiring. In between the painter would disappear into the adjacent room to chat with his models, who were always present. After six months Friederike Maria Beer literally carried off the picture, as Klimt seemed disinclined to declare it finished. After his death in 1918, she classified and stamped the drawings from the artist's estate in the Galerie Gustav Nebehay. After a short marriage to the Italian Emanuel Monti, Friederike Maria Beer met the American Hugh Stix in 1932 and a few years later emigrated to the United States, where she ran the 'Artist's Gallery', which Stix had founded. He promoted American artists and also supported Austrian emigrants after 1938.

Baby, 1917

Oil and tempera on canvas
110 × 110 cm
National Gallery of Art, Washington, D.C.

Klimt seems to have been good with children, judging by the photos from holidays with the Flöge family. He himself had six children by three women: offspring whom he financially supported but never adopted. Even his early works feature small children and babies in the form of cherubs, and they appear again later in the Faculty pictures and works on the subject of the cycle of life. Perhaps this picture should be seen in this context and it was to be expanded by further pictures to form a cycle. It is not certain whether Klimt regarded the picture as completed. The canvas has remained unworked in many places and the black graphite lines of the preliminary drawing are still visible. The painter showed the painting as early as September 1917 in Stockholm. However, it was not unusual for him to exhibit works that he later went on to complete or even modify extensively. At any rate, the start of his work on *Baby* has been recorded: 11 August 1917, when he wrote to Emilie Flöge that he intended to make a start that very day.
Klimt shows the child from a perspective that he did not usually adopt for his portraits, as he preferred to paint his models from the front view. In the first instance this is because the baby is too small to pose in the usual manner. Klimt could, however, have positioned it lying down and portrayed it from above as Egon Schiele did in 1916 in his gouache *Portrait of a Child (Anton Peschka, Jr.)*. Similar to Klimt's baby, Schiele's little nephew is wrapped in a boldly coloured patterned blanket; the surroundings are also undefined, because Schiele leaves the white paper unworked. Klimt's perspective, however, enables him to structure the composition in a large triangle which he often uses in his portraits and which can be worked through here in pure, simplified form. Thus the child almost disappears against a greenish-brown background in a mountain of colour and ornamentation that is piled up before the viewer's eyes. Only the little head, with the left cheek covered by frills, and the right hand are visible. The possibly unfinished state of the picture is very attractive; the brushwork is carefree and casual, and the palette includes many mixed colours in addition to an intense yellow, red and blue – not only the pink which shines out, but also others which are not necessarily considered 'pretty', but which are artistically interesting. Some sections look like abstract painting.

Johanna Staude, 1917 (unfinished)

Oil on canvas
70 × 50 cm
Belvedere, Vienna

This blouse would be the height of fashion even today. The pattern looks as contemporary as the lively face of its wearer, who gazes at us confidently with an alert expression. The painting is equally fresh – with soft brushstrokes and colours in brilliant complementary contrasting shades of orange and turquoise, blue and violet. The free painting style leaves the canvas visible in places. The skin has been dabbed on using pink shimmering with mother-of-pearl and white as well as a delicate blue in the shadowed areas to give three-dimensionality to the cheeks, nose, eyes and chin. The eyes are bright and clear with added lights and a dark edge around the iris; the brown hair lies in shining waves and the mouth is a delicate coral pink. The lines of the preliminary drawing are still visible. The silk blouse with the large turquoise leaves suits Johanna Staude admirably. A feather boa wrapped around her neck emphasises her face. Klimt has chosen a small format and the form of a head-and-shoulders portrait – unusual for his portraits of women whose names we know. It enables him to bring the model close to the viewer, exposing her to the intimate gaze.

When Klimt painted this portrait, Johanna Staude, born in Vienna in 1883 as Johanna Widlicka, was working as a language teacher. She was married to Franz Staude from 1914 until 1918. Her brothers Leopold and Anton were artists and her brother Richard an opera singer. She herself is also listed in a Vienna address book after 1950 as an artist, although no works by her are known. Johanna Staude modelled for Gustav Klimt and Egon Schiele on several occasions. This portrait, however, and a corresponding preliminary drawing were amongst her possessions. So could it have been a commissioned portrait? Klimt seems to have liked Johanna Staude very much. He always took care of his models, so he probably arranged a position for her in the home of the writer Peter Altenberg, in whose household she later worked. It is also said that Klimt's answer to her question as to why he did not finish the portrait, and especially the mouth, was: 'Because then you would never come back to my studio.' Four years before her death in 1967, Johanna Staude sold the portrait to the Österreichische Galerie Belvedere. The silk blouse is also preserved there. It had been made by the Wiener Werkstätte; the fabric pattern *Blätter* (Leaves) was designed by Martha Alber, who worked there in the textiles department.

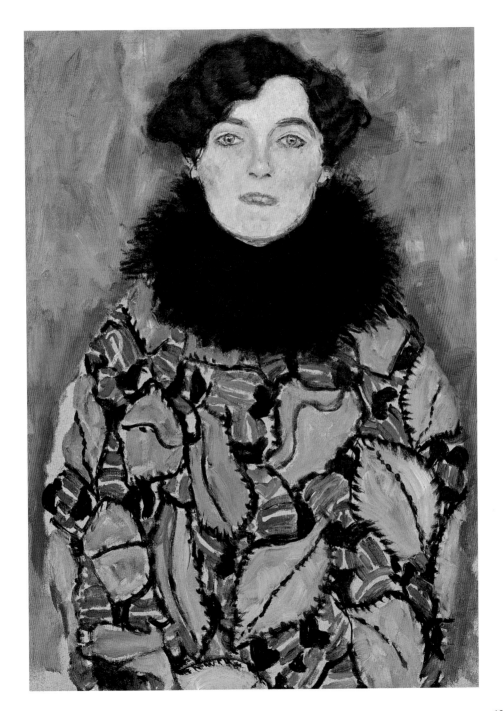

Lady with Fan, 1917

Oil on canvas
100 × 100 cm
Private collection

An aura of mystery seems to surround the lady with the fan. We do not know who she was. Serene and fully aware of the effect that she creates, Klimt's lovely subject looks sideways into the distance, her head with its piled-up hairstyle erect on her long neck. A gentle smile plays around her lips. She has allowed her robe to slip off her left shoulder in a casually seductive manner. She desultorily covers her naked breast with her fan.

The main harmony of the painting is provided by the three primary colours yellow, blue and red. They are complemented by their blended colours together with white and black. Yellow is the dominant colour. Klimt has applied it in various nuances with broad brushstrokes. Its metallic gleam is perhaps a lingering resonance from his 'Golden Phase' and a reminiscence of the gold backgrounds of the Japanese Rimpa School. It lends the picture a festive, somewhat alien mood. The palette of blue shades extends from the deep dark blue in the fan to the greenish-blue of the robe to the powerful ultramarine mixed with white, and into shades approaching violet. Klimt has applied red as an intense carmine and in variations of pink and orange.

Klimt has drawn extensively on large-scale subjects from East Asia – the phoenix, the crane and the lotus blossom – for the ornaments with which he has surrounded the lady. He found them amongst his collection of Chinese and Japanese garments and objets d'art, and greatly enlarged the decor and motifs. The pattern on the robe, in which the forms of the surroundings are concentrated in detail, seems to fuse with the background. The black-and-white stripes on the sleeves are particularly charming; they correspond with the black wing feathers of the bird at top left. Klimt translates the inspiration from different eras and arts into an autonomous, free painting style.

Together with *The Bride*, this picture was found unfinished on the easel in Klimt's studio after his death. It was also of particular public interest because, for over a hundred years after its creation, it was only on view in Austria on a single occasion: in the Viennese Art Exhibition in 1920. It was finally shown there again in 2021, in the Belvedere, in an exhibition of Klimt's late works named after this painting.

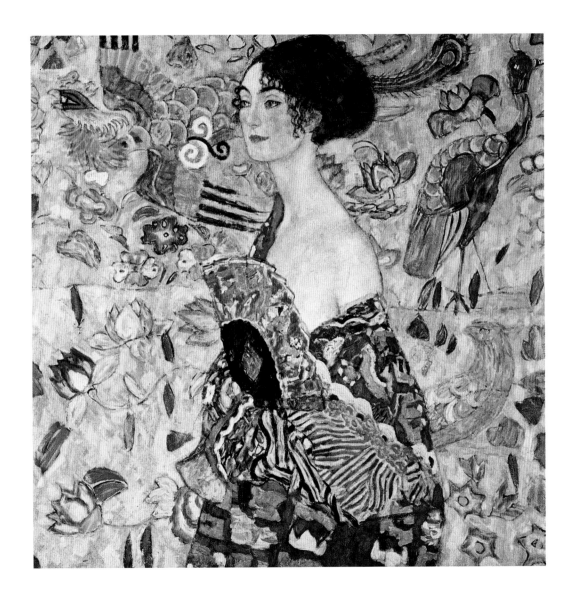

Adam and Eve, 1916–1918 (unfinished)

Oil on canvas
173 × 60 cm
Belvedere, Vienna

This is one of Gustav Klimt's last pictures – and one which he did not finish. It is the artist's only painting showing the Biblical subject of Adam and Eve, one of the major topics throughout art history. Klimt's portrayal does not correspond with the usual iconography, nor does it match the way in which he has hitherto chosen to depict couples. In *The Kiss*, the *Beethoven Frieze* and the *Stoclet Frieze* the man is shown in front as the active partner, while the woman is his devoted associate. Here, however, it is the radiant nude body of Eve that dominates the painting and obscures the figure of Adam except for his head and arms. The brownish shade of his skin makes him recede entirely into the background, so that he is little more than a film which envelops the female body and shows it to even better advantage. Adam's eyes are closed; his head position seems languorous and at the same time protective. Eve's eyes, by contrast, are wide open and she directs her gaze towards the viewer, full of zest for life and with her head inclined coquettishly and yet innocently to the right. Her sophisticated pose is underlined by the silhouette of her body, outlined with dark contours, and her angelic long blond curls which cling to her. Eve's translucent skin shimmers in delicate hues in shades of white, pink, soft blue and green which give three-dimensionality to her body and contrast with the dark spots of the leopard skin. The latter is not merely decorative, but also underlines the erotic mood of the picture. Evidently Klimt intended to extend it on the left up to the middle of the picture. On the still unworked section of canvas, we can recognise the preliminary drawing for Eve's right hand. Her feet are covered with anemones. A small dark-blue flower can be seen in her hair, and a large orange-red one glows on the leopard skin – blossoms which form an echo to the salmon-pink nipples on Eve's breasts. Klimt uses the Biblical subject, which justifies the representation of the nude female body, in order to celebrate female beauty and its erotic attractions. The figure of Eve radiates an attractiveness that is not artificial but natural, almost innocent.

The painting was shown in the 1919 exhibition of Klimt's estate in the Galerie Gustav Nebehay, where it was purchased by the artist's friend and patron Sonja Knips. It has belonged to the collection in the Belvedere since 1950.

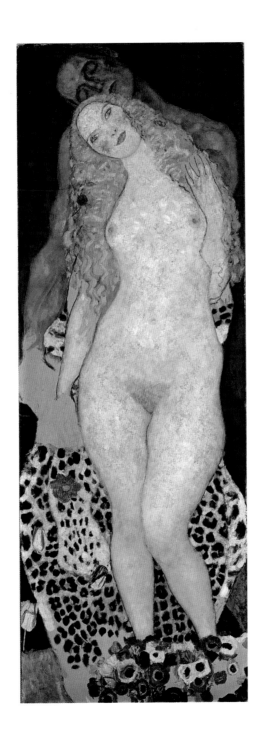

The Bride, 1917/18 (unfinished)

Oil on ca /as
165 × 191 cm
Belvedere, Vienna (loan)

The bride is wearing blue. She plays the leading role and occupies the centre of
the picture. With her eyes closed and an ecstatic smile on her face, she is leaning
against the shoulder of a man who has gently inclined his head towards her. The
position of her head and her facial expression recall other representations of women
with their eyes closed, such as *The Kiss* and the allegory *Death and Life*. In those
works, too, similarly entangled bodies can be seen. Klimt often used forms he had
invented more than once. The nude seen from the rear is familiar from the painting
Goldfish. At more or less the same time, Klimt dedicated a separate picture to the
subject of the baby. But there is one thing that he had not done since 1900: to paint
the facial features of a man.

Klimt made extensive preparations for the composition with more than 150
drawings, but the work on the oil painting came to an abrupt end with his death.
It therefore allows us an insight into the artist's working method. The overall
arrangement has already been clearly defined – whereby Klimt would even make
major changes to his works after they had already been exhibited. Some of the
faces on the left-hand side of the picture, as well as that of the bride, seem to
have been depicted almost completely. Hair, bodies and fabrics are unfinished,
however. We can deduce, from the left arm of the woman in front of the male
figure, how Klimt would first make a rough sketch with a graphite pencil before
outlining the precise contours with black paint. Some shades of pink, yellow, blue
and grey for the flesh tones have already been applied. Klimt would later add
white with short brushstrokes, which would blur the black outlines and allow the
colourful underpainting to shine through. In this way he could create the porcelain
skin tone of the nude seen from the rear. On the right-hand side of the picture the
bride's dress is first marked out as an underpainting; the canvas is still completely
unworked in parts. The area between the bride and the figure on the right is not
yet shown in detail, apart from a head. The nude woman with her legs spread wide,
openly displaying her genitals, would of course have been a provocation for the
public of the time, but that cannot have been the reason for Klimt beginning to
paint a skirt over the top.

It is difficult to interpret the painting. Is the bride dreaming of her wedding night?
Or is the work a variation of the allegory of *Death and the Maiden*, as painted by
Klimt's young artist friend Egon Schiele in 1915? In any case, the proximity of life and
death was a perpetual theme for Klimt.

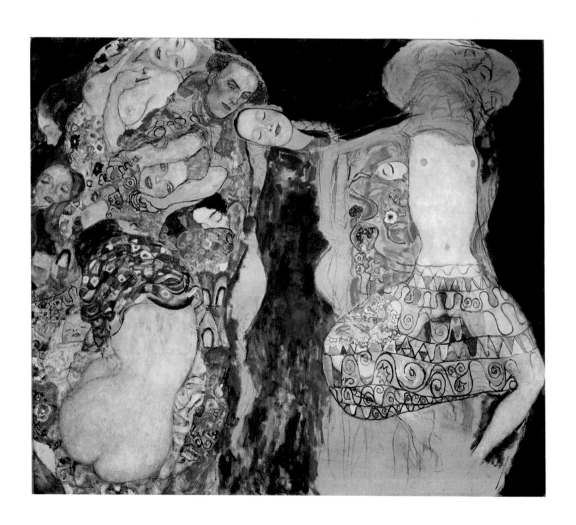

FURTHER READING

Bisanz-Prakken, Marian (ed.), *Gustav Klimt: Drawings*, catalogue for the exhibition in the Albertina, Vienna, and the J. Paul Getty Museum, Los Angeles, Munich 2012

Brandstätter, Christian (ed.), *Vienna 1900: Art, Life & Culture*, London/New York 2006

Dean, Catherine, *Klimt*, London 2020

Husslein-Arco, Agnes, and Alfred Weidinger (eds.), *Gustav Klimt: Life and Work*, Berlin 2014

Husslein-Arco, Agnes, and Alfred Weidinger (eds.), *Gustav Klimt & Emilie Flöge: Photographs*, Munich/London/New York 2012

Husslein-Arco, Agnes, and Alfred Weidinger (eds.), *150 Years Gustav Klimt*, catalogue for the exhibition in the Belvedere, Vienna, Vienna 2012

Kallir, Jane, and Alfred Weidinger, *Gustav Klimt: In Search of the "Total Artwork"*, Munich/London/New York 2009

Koja, Stephan, and Manuel Fontán del Junco (eds.), *Gustav Klimt: The Beethoven Frieze and the Controversy over the Freedom of Art*, Munich/London/New York 2006

Koja, Stephan (ed.), *Gustav Klimt: Landscapes*, Munich/London/New York 2019

Natter, Tobias G., and Christoph Grunenberg (eds.), *Gustav Klimt: Painting, Design and Modern Life*, London 2008

Natter, Tobias G., *Gustav Klimt: The Complete Paintings*, Cologne 2017

Natter, Tobias G., *Klimt and the Women of Vienna's Golden Age, 1900–1918*, Munich/London/New York 2016

Natter, Tobias G., Franz Smola and Peter Weinhäupl (eds.), *Klimt: Up Close and Personal: Paintings – Letters – Insights*, Vienna 2012

Natter, Tobias G. (ed.), *Klimt's Women*, New Haven 2000

Natter, Tobias G., and Max Hollein (eds.), *Klimt & Rodin: An Artistic Encounter*, Munich/London/New York 2017

Partsch, Susanna, *Gustav Klimt: Painter of Women*, Munich/London/New York 1994

PHOTO CREDITS